IMAGES
of America

WATERTOWN

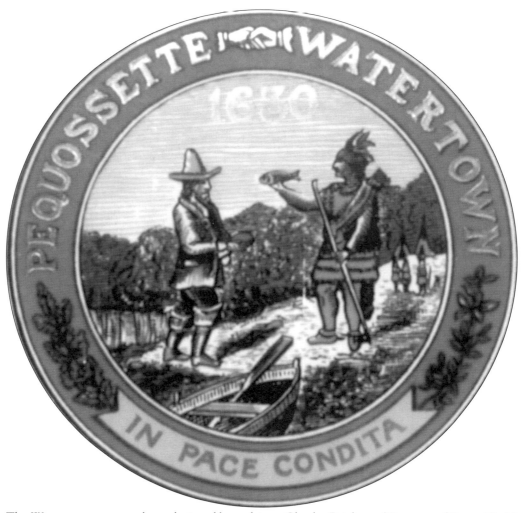

The Watertown town seal was designed by architect Charles Brigham. (Courtesy of Roger Hird.)

IMAGES
of America
WATERTOWN

Friends of the Watertown
Free Public Library and
the Historical Society of Watertown

ARCADIA

First printed in 2002.

Published by Arcadia Publishing,
an imprint of Tempus Publishing, Inc.
2A Cumberland Street
Charleston, SC 29401

Printed in Great Britain.

Library of Congress Catalog Card Number: 2001099424

For all general information contact Arcadia Publishing at:
Telephone 843-853-2070
Fax 843-853-0044
E-Mail sales@arcadiapublishing.com

For customer service and orders:
Toll-Free 1-888-313-2665

Visit us on the internet at http://www.arcadiapublishing.com

CONTENTS

ACKNOWLEDGMENTS

This book would not have been possible without the resources of the Watertown Free Public Library. The library's extensive archive of historical photographs and its comprehensive Web site proved to be invaluable. All photographs used in this book, unless otherwise noted, are courtesy of the library.

Many people contributed their time, knowledge, and personal photographs. We would like to acknowledge the contributions of Kristen Farmelant, Dawn Scaltreto, Rita Loughlin Scudder, Christine Loughlin Diamond, Robert B. Chase, J. Malcolm Whitney, Charles Morash, Jean Berry, Mark Harris, Carole Katz, and Susan V. Wawrzaszek. Special thanks go to Ruth Thomassian of Project SAVE.

Three earlier works were consulted during the research for this book: *Great Little Watertown: A Tercentenary History*, by G. Frederick Robinson and Ruth Robinson Wheeler (Higginson Book Company, 1930); *Watertown Papers*, by Charles T. Burke (Historical Society of Watertown, 1989), and *Crossroads on the Charles: A History of Watertown, Massachusetts*, by Maud deLeigh Hodges (Phoenix Publishing, 1980).

We hope that reading this book will be as illuminating and rewarding for the reader as researching and writing it was for each of us.

Authors:

Patricia Ahern, President, Friends of the Watertown Free Public Library
Kathy Alpert, President, PostMark Press Inc.
Leone Cole, Director of the Watertown Free Public Library and Arcadia project coordinator
Joyce Kelly, Editor, Watertown Historical Society newsletter *The Town Crier*
Beverly Shank, Supervisor of Adult Services, Watertown Free Public Library
Sigrid Reddy Watson, President, Historical Society of Watertown

INTRODUCTION

The "city known as the town of Watertown" has a long and rich history. Settled in 1630, Watertown was the first inland settlement in Massachusetts. Its borders originally encompassed the present-day towns of Waltham, Weston, and Belmont, as well as parts of Cambridge, Concord, Lincoln, Lexington, and Wayland.

The photographs in this book celebrate the diversity and importance of this town on the crossroads of the Charles River. Watertown was the seat of the Revolutionary government in the early years of our country, hosting such figures as John and Samuel Adams, John Hancock, and Paul Revere. Watertown has provided munitions to the U.S. military from one of the country's oldest arsenals, established in 1816 by Pres. James Madison. Watertown has played host to presidents from George Washington to Franklin Roosevelt. From the Puritans of the 17th century to the Armenians and Russians of the 20th century, Watertown has offered opportunities for people to start anew and thrive.

Watertown can claim many firsts. The town was the site of the first treaty signed by the newly created United States of America with a foreign power—the Miqmaq Indian Nation of Canada. The Bemis Mills produced the first sailcloth manufactured in the United States and furnished the sails for the frigate *Constitution*. The Elliott quadricycle, the addressograph, and the Stanley steamer were invented in Watertown, as was frozen pizza.

In the mid-19th century, Watertown was a thriving social and artistic center. Notable residents included Lydia Maria Child, Lucy Stone, Anne Whitney, Harriet Hosmer, Ellen Robbins, and Celia Thaxter. The Watertown Free Public Library opened in 1869 on the first floor of the town hall. It soon outgrew this space and, following a fundraising drive, moved into a new building in 1884. This building is still in use as part of the town's main library.

The photographs here also document Watertown's development into a major industrial center in the early 20th century. Well-known manufacturers such as the Aetna Mills (now the site of Boston Scientific), Haartz-Mason Coated Fabrics, the Hood Rubber Company, and Lewando's Cleansing and Dyeing left their stamp on Watertown's development.

Other changes in the early 20th century helped shape Watertown's destiny. In 1912, the Boston Elevated Street Railway was extended to Watertown, providing cheap and convenient transportation to and from Boston. Watertown became a streetcar suburb. The Perkins School for the Blind relocated to Watertown from South Boston in 1912. From 1920 to 1930, the town increased in population from 21,000 to nearly 35,000. Later in the 20th century, the town

meeting form of government was replaced by a manager-council system. Science and technology firms also moved into the town.

We hope you enjoy these glimpses of the oldest inland settlement in Massachusetts.

One
EARLY WATERTOWN

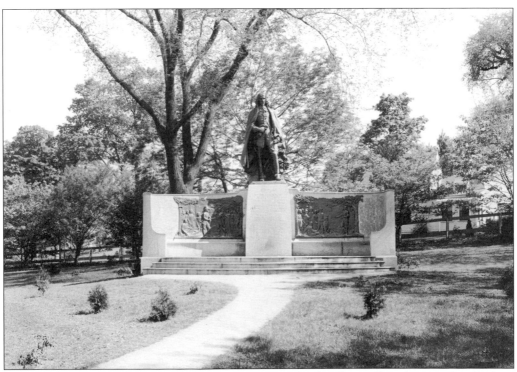

The Founders' Monument features a figure of Sir Richard Saltonstall and, on each side, bas-reliefs of Roger Clap's landing and the antitax protest for which Watertown's founder and its first minister, George Phillips, later became famous. It is inscribed, "To the founders of Watertown whose protest against taxation without representation struck the first note of civil liberty here in this wilderness."

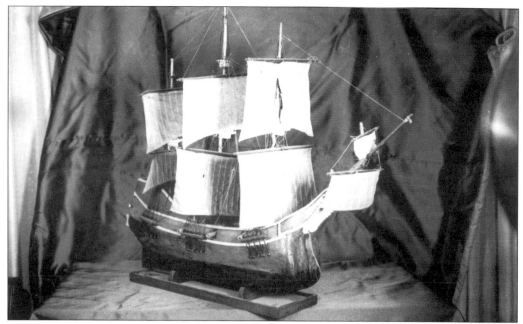

This model of the *Arbella*—the ship that brought Sir Richard Saltonstall, Rev. George Phillips, and many other original settlers of Watertown from England—is in the First Parish Church. The *Arbella* departed from Yarmouth on the Isle of Wight on April 8, 1630, and arrived in Salem on June 12, 1630.

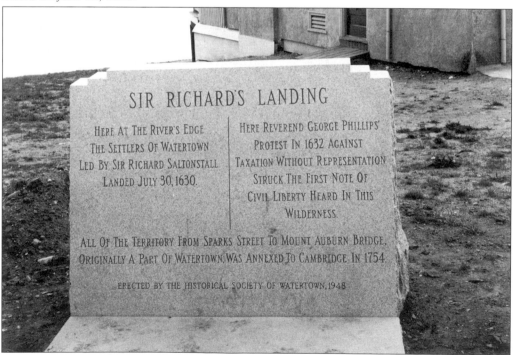

SIR RICHARD'S LANDING

HERE AT THE RIVER'S EDGE
THE SETTLERS OF WATERTOWN
LED BY SIR RICHARD SALTONSTALL
LANDED JULY 30, 1630.

HERE REVEREND GEORGE PHILLIPS'
PROTEST IN 1632 AGAINST
TAXATION WITHOUT REPRESENTATION
STRUCK THE FIRST NOTE OF
CIVIL LIBERTY HEARD IN THIS
WILDERNESS.

ALL OF THE TERRITORY FROM SPARKS STREET TO MOUNT AUBURN BRIDGE,
ORIGINALLY A PART OF WATERTOWN, WAS ANNEXED TO CAMBRIDGE IN 1754.

ERECTED BY THE HISTORICAL SOCIETY OF WATERTOWN, 1948

A granite tablet marks the Saltonstall party's landing on July 30, 1630, on the shores of the Charles River. Originally a part of Watertown, the territory from Sparks Street to the present boundary on Mount Auburn Street was annexed to Cambridge in 1754.

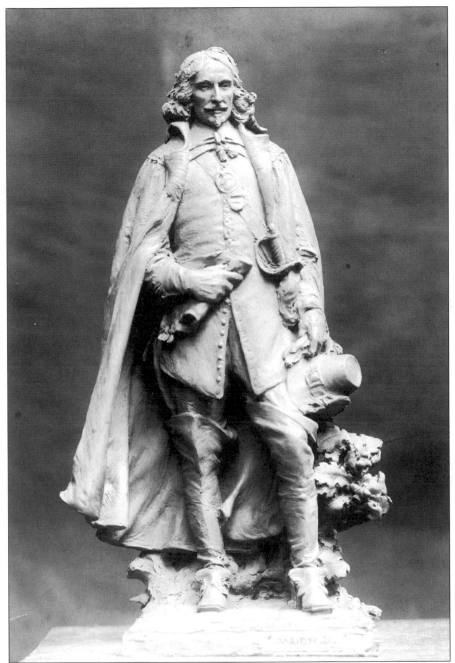

The commanding figure of Sir Richard Saltonstall stands in the center of the Founders' Monument on Charles River Road. The sculpture is the work of Henry Hudson Kitson. The monument was built in 1935 with money raised by G. Frederick Robinson. It is inscribed with a quotation from Sir Richard in a letter to John Wilson and John Cotton (ministers in Boston in Governor Winthrop's government): "I hope you do not assume to yourselves infallabilitie of Judgement when the most learned of apostles confesseth that he knew but in parte and saw but darkely as through a glass . . . that the Lord would give you meeke and humble spirits not to stryve so much for uniformity as to keep the unity of the spirit in the bond of peace."

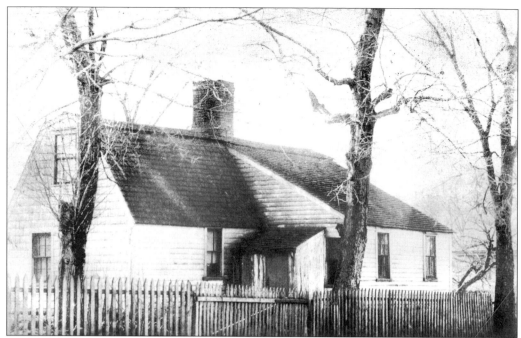

Thomas Mayhew, the builder and later owner of the gristmill on the Charles, built this house in 1634 near the mill. He built the first bridge across the Charles at Watertown, purchased land on both sides of the Charles River, and served in town and colony offices. In 1645, Mayhew moved to Martha's Vineyard, where his son Thomas Mayhew Jr. ministered to the Native Americans. As governor of Martha's Vineyard, the elder Mayhew lived to the age of 91.

The gristmill was built in 1634 by Thomas Mayhew to grind grain for local farmers. At the center of town, it stood in Watertown Square for 300 years near an arc-shaped canal that deflected water to the mill from a stone dam on the Charles River. The oldest millrace in America in continuous use, Mill Creek was eventually filled.

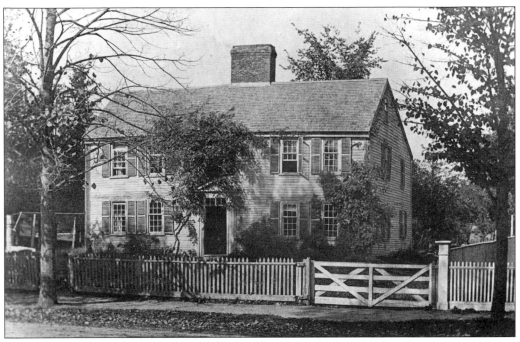

The Old Parsonage, also known as the Bailey House, was built in 1685 at the corner of Mount Auburn and Arlington Streets. Its first occupant was Rev. John Bailey. Succeeding ministers who lived here include Henry Gibbs, Seth Storer, Daniel Adams, and Richard Rosewell Eliot.

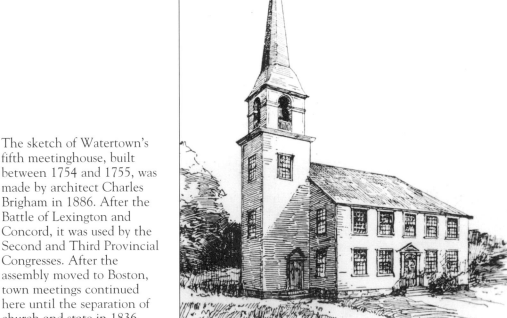

The sketch of Watertown's fifth meetinghouse, built between 1754 and 1755, was made by architect Charles Brigham in 1886. After the Battle of Lexington and Concord, it was used by the Second and Third Provincial Congresses. After the assembly moved to Boston, town meetings continued here until the separation of church and state in 1836.

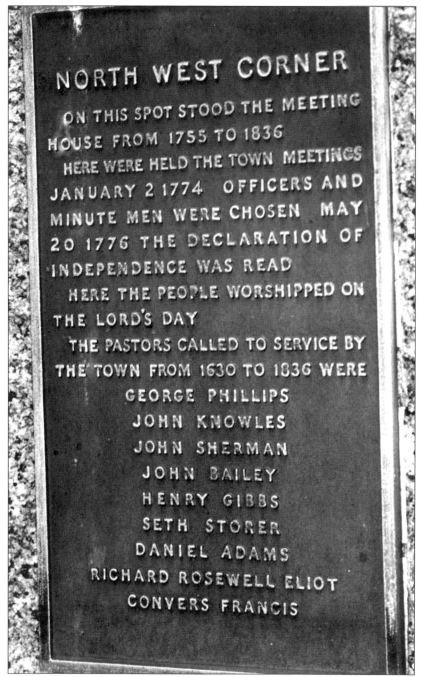

NORTH WEST CORNER
ON THIS SPOT STOOD THE MEETING
HOUSE FROM 1755 TO 1836
HERE WERE HELD THE TOWN MEETINGS
JANUARY 2 1774 OFFICERS AND
MINUTE MEN WERE CHOSEN MAY
20 1776 THE DECLARATION OF
INDEPENDENCE WAS READ
HERE THE PEOPLE WORSHIPPED ON
THE LORD'S DAY
THE PASTORS CALLED TO SERVICE BY
THE TOWN FROM 1630 TO 1836 WERE
GEORGE PHILLIPS
JOHN KNOWLES
JOHN SHERMAN
JOHN BAILEY
HENRY GIBBS
SETH STORER
DANIEL ADAMS
RICHARD ROSEWELL ELIOT
CONVERS FRANCIS

This marker in Common Street Cemetery, at the intersection of Common and Mount Auburn Streets, stands at the northwest corner of the fifth meetinghouse. All four corners of the meetinghouse are memorialized by granite shafts. After the Battle of Lexington and Concord, the Third Provincial Congress met here from May 31, 1775, to July 19, 1775, after which that body reorganized as the General Court of Massachusetts. It continued to meet at this location until November 19, 1776. The building was demolished in 1837. The pastors listed served as the town's ministers until the disestablishment of the Congregational Church in 1836.

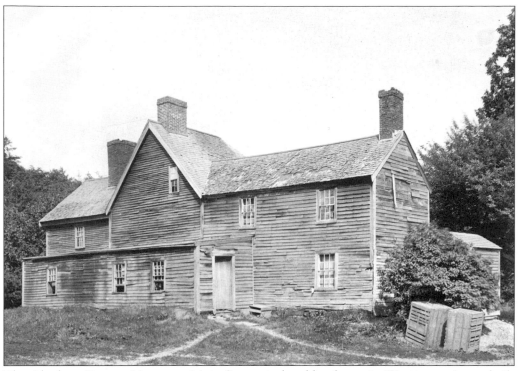

The Abraham Browne House, on Main Street, is the oldest house in Watertown. It was built by Abraham Browne c. 1698 on land he had inherited from one of the first settlers, also Abraham Browne, a surveyor, whose original land grant consisted of 60 acres. The house is noted for its large original fireplace, hand-hewn beams, and a rare 17th-century triple window with small diamond panes in a second-floor chamber.

The Coolidge Homestead stood on Grove Street, near the Arlington Street Cemetery. When the call to arms came on April 19, 1775, Joseph Coolidge, the town's tax collector and a descendant of one of the founding families, left his plow, shouldered his gun, and guided the Natick Company to the battle in Lexington. To honor him as the only Watertown man killed on that day, his descendants erected a 17-foot obelisk.

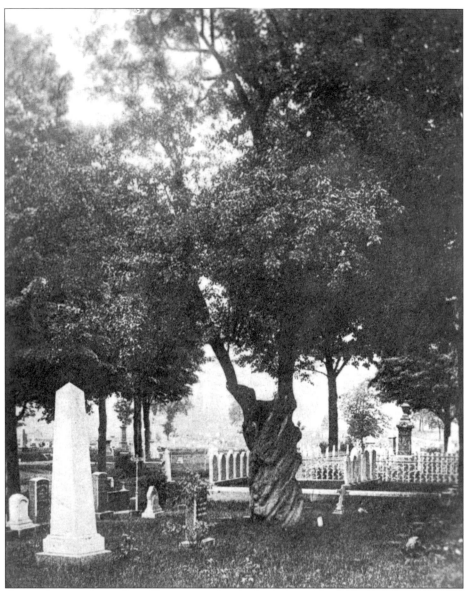

Dea. Simon Stone's Great Pear Tree was said to be 285 years old when it was cut down in 1921. It was located on the Simon Stone farm, in an area near the Charles River that is now part of the Cambridge Cemetery. Another large portion of the Simon Stone farm, known as Stone's Woods, was purchased by the Massachusetts Horticultural Society in 1831 to create an arboretum, which became Mount Auburn Cemetery. On September 12, 1899, the historical society sponsored an outing to see the old pear tree, which had been planted by Simon Stone. Among the guests was famous sculptor Harriet Hosmer. Mathew Stone spoke about his ancestors who had farmed the land, after which the group ate fruit from the tree. Society president Edward Rand marked this occasion by expressing the value of the society's work "in saving the past . . . for the future." A record of this outing and the names of all attendees were written down and placed in a box that was to be set in the cornerstone of the Baptist church, in construction at the time at the corner of Common and Mount Auburn Streets. The church remains there today.

Two
THE CHARLES RIVER

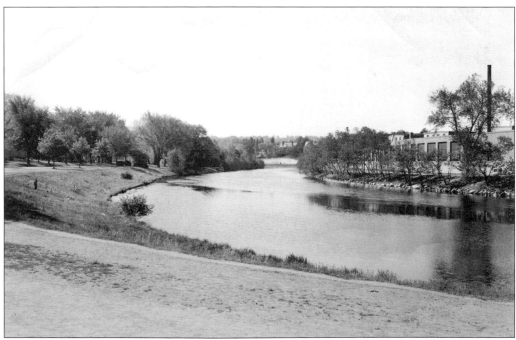

The new Charles River Road is pictured here when it opened early in the 20th century. The roadway was built after construction of the Charles River Dam eliminated the river tides. Looking downstream, one can see how the south side of the river remained industrial while other sections were given over to recreation. The Stanley Brothers–Bachrach Building pictured is said to be the first poured-concrete building in America.

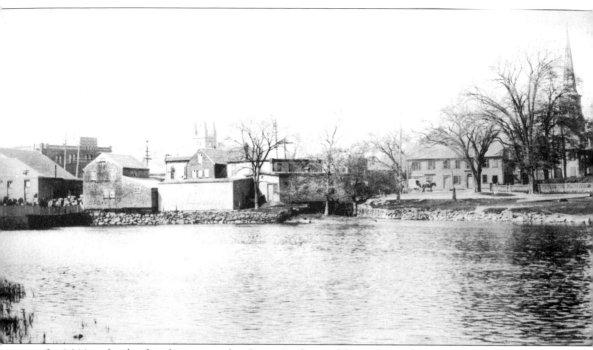

In 1641, a footbridge, known as the Great Bridge and later the Galen Street Bridge, was built across the river where the Boston Road (now Galen Street) connected to the Sudbury Road (now Main Street). In the early years, it was the only route to the towns west of Boston. The bridge was wide enough for foot traffic only and had to be widened for horses in 1648. In 1719, it was widened for carriages. It did not undergo a major reconstruction until 1908. For many years, the cost of maintaining this busy thoroughfare was a matter of dispute between Watertown and neighboring communities.

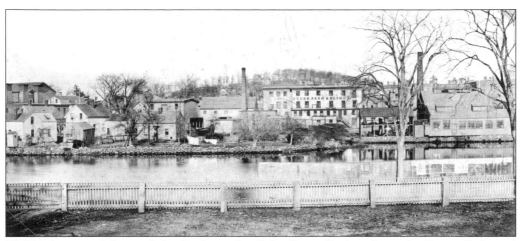

This early view of the north bank, above the Galen Street Bridge, shows the Doors, Sash, and Blind Company and the surrounding houses. From the earliest days, people both lived and worked along the banks of the Charles.

In the 17th century, the rapids above what is now Watertown Square were harnessed to power the Watertown Gristmill. The canal that bore water for the mill, shown here c. 1835, was known as Mill Creek. The creek was later filled in and became the site of Lewando's Cleansing and Dyeing. Governor Winthrop recorded the story of a young boy who fell into the canal and was carried downstream and under the wheel, and emerged unhurt.

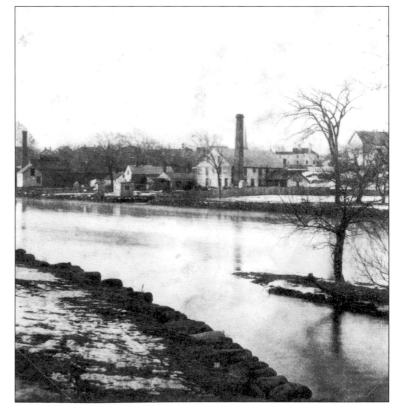

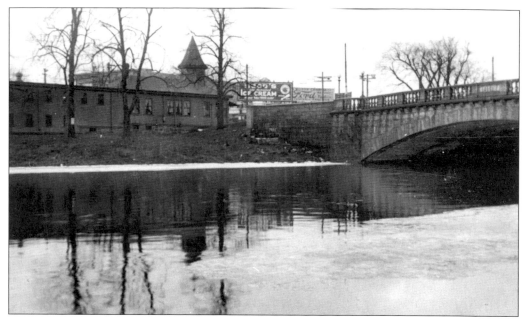

The carbarns for the Boston Elevated Street Railway are seen in this view of the river and the Galen Street Bridge. If this photograph were taken today, it would be taken from the Watertown dock and would show the Massachusetts Bay Transit Authority yard.

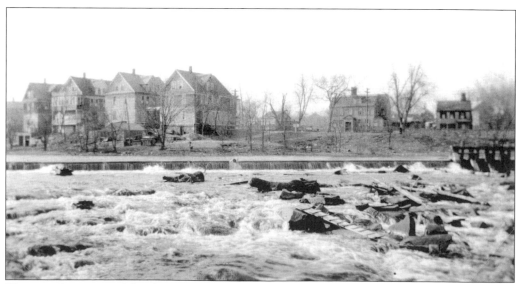

This is a depiction of floodwaters on the north bank, showing the dam and houses c. 1866. Before the Charles River Dam was built, the river was tidal. In many places, the banks were flat and low, and in some locations above the Watertown dam, stone reinforcements were built.

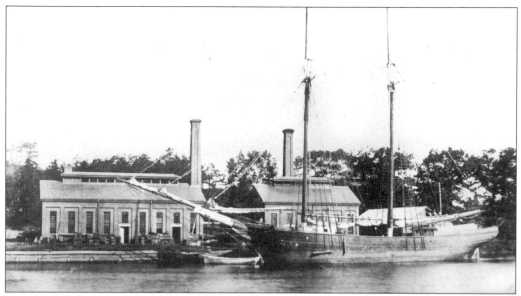

In the early days, the Charles River in Watertown was a gateway to points inland for travelers and shippers. The river was tidal, and it remained a commercial waterway until the early 1900s. Schooners like this one, shown here in front of the Arsenal Gas Company in 1875, regularly traveled the river.

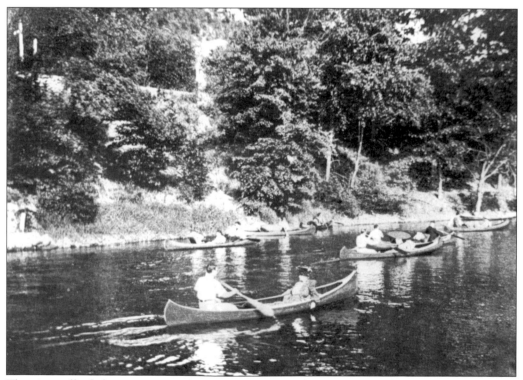

The river afforded opportunities for recreation even when its primary function was industrial, before it was dammed. One of the oldest forms of recreation is boating, popular since the mid-19th century. This 1910 postcard shows canoeists enjoying the river.

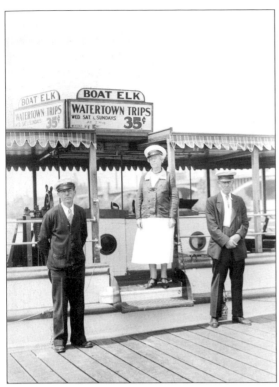

The sightseeing boat *Elk* cruised along the Charles in the 1930s. As the river in Cambridge and Watertown took on a more recreational character, the schooners were replaced by cabin cruisers and yachts. Yachting, racing, and ice-skating became popular when the mud flats became land and the boundaries of the river became more defined.

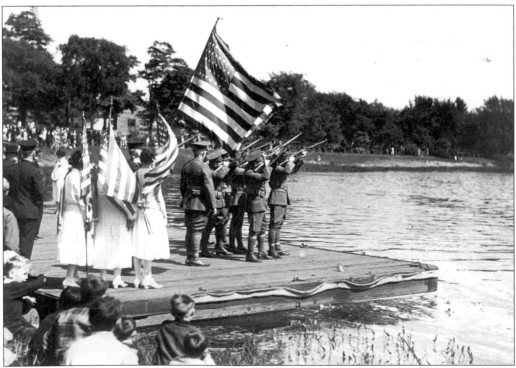

The banks near Watertown Square have been the scene of town celebrations for over a century. At this 1927 Memorial Day observance, soldiers fire a salute from the Watertown dock.

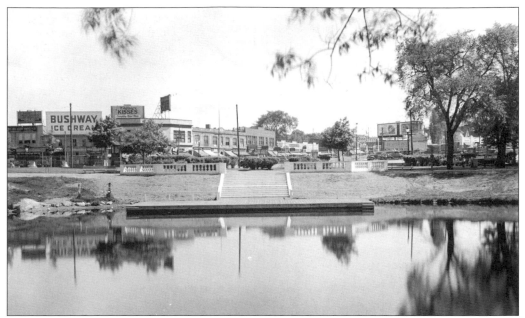

This view, looking up Mount Auburn Street, shows a boat landing. Much of the land along the river was publicly owned, as it still is. The Metropolitan Park Commission (later the Metropolitan District Commission) formalized this by acquiring 30 miles of riverbank in 1903.

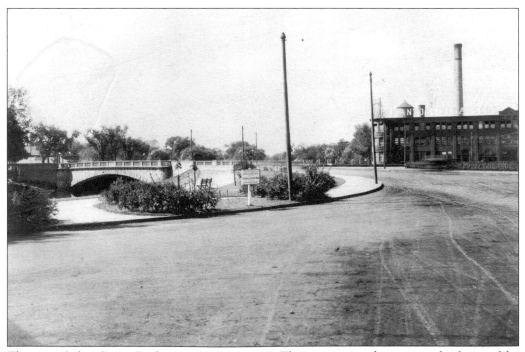

The new Galen Street Bridge was built in 1908. The concrete and granite arch, designed by town engineer Wilbur Learned, replaced the old planks. The road was spread out at both ends to accommodate the newest vehicles. The stone balustrades that line both sides of the bridge were designed for beauty as well as for utility.

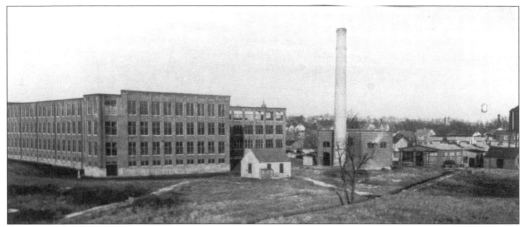

Water from the Charles supplied a variety of mills as manufacturing took hold. Products of these mills included soap, candles, paper, and (in the early 1800s) cotton. A thriving working-class population of mill workers grew along the riverbanks. The Earnshaw Knitting Mills, manufacturer of Vanta baby clothes, are shown here surrounded by the homes of the mill workers. The proximity of workers' living quarters to their mills was a typical arrangement.

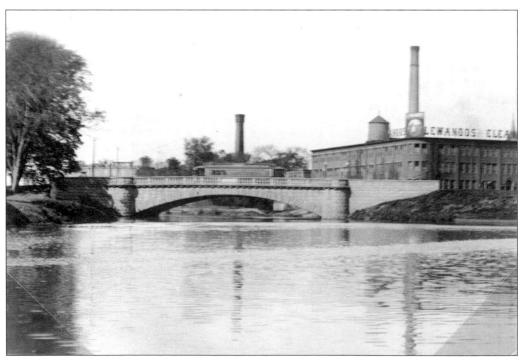

This is the Galen Street Bridge in 1906, just before it was rebuilt.

Three
TRANSPORTATION

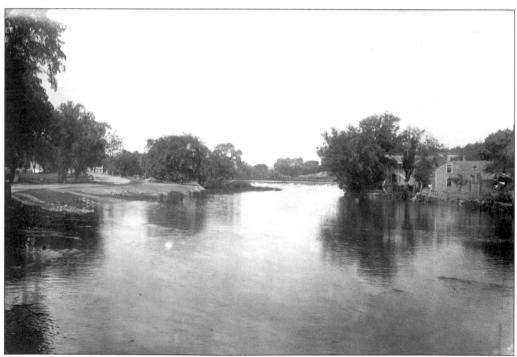

Travelers heading west from Boston often forded the Charles River at the shallows in Watertown. The river itself was an important artery for transporting goods and people. Boatbuilding and ferrying were major riverside occupations in 18th-century Watertown. In 1875, schooners were sailing upriver near the arsenal, but deep-river traffic never came. A late-19th-century effort to dredge the river did not occur, in spite of a pledge of federal money.

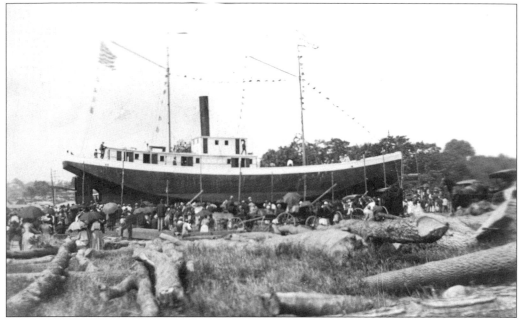

In 1890, the 400-ton SS *Watertown*, the first steamer on the Charles River, was launched from a North Beacon Street wharf. Built by successful Boston wine merchant John Cassidy, the ship carried both passengers and freight to Boston Harbor until it burned in 1893.

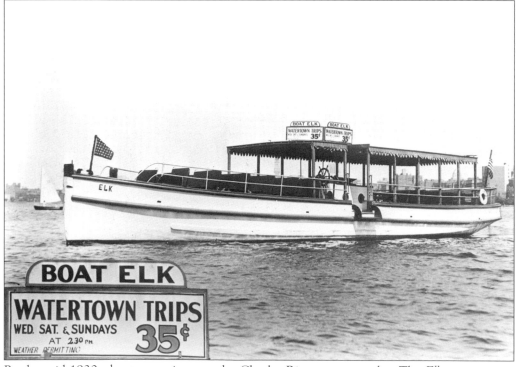

By the mid-1930s, boat excursions on the Charles River were popular. The *Elk*, an open-air sightseeing vessel, took customers on afternoon trips from Watertown around Boston Harbor for 35¢.

Antipas Jackson built his blacksmith business on Arsenal Street near Watertown Square. Foot traffic from the earliest days of the Pequossettes wore paths along the river through Watertown. Later, roads followed these paths. Horses eventually gave way to bicycles, and, in turn, to steam- and gasoline-powered vehicles as the traffic on these roads increased. By the mid-19th century, horses and carriages transported Boston folks who were visiting Watertown's large estates, its famous arsenal, or the new garden cemetery and arboretum at Mount Auburn. By 1853, Watertown had new graveled roads, sidewalks, and named streets with signposts. The old Baptist church is on the right in this photograph.

The 19th century saw revolutionary changes in transportation, but Kelly's hotel and harness shop on Arsenal Street, formerly owned by Thomas Patten, was still in business in 1916.

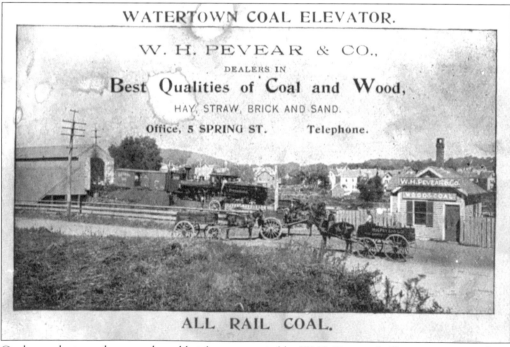

Coal, wood, straw, hay, sand, and brick were carried by W.H. Pevear & Company wagons from their Spring Street location *c.* 1890.

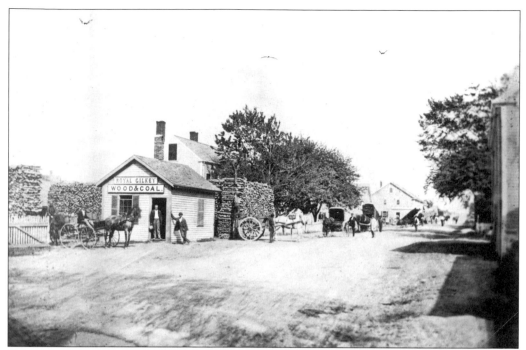

Horses drew both carriages for people, and wagons for Royal Gilkey's wood and coal business on Patten and Arsenal Streets c. 1890.

Thomas P. Emerson owned Watertown Express, located on the site of the Spring Street hotel sheds, c. 1893. His business conveyed goods between Watertown and Devonshire Street in Boston.

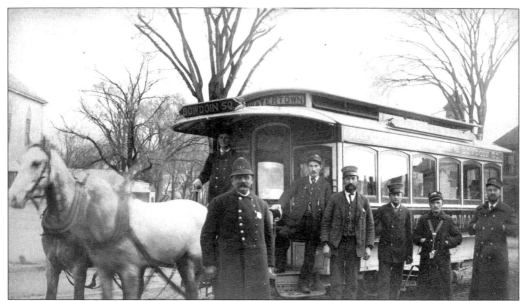

In 1857, the first horsecar line brought passengers from Watertown to Boston. The crew in front of this horse-drawn trolley includes Chief Parker, ? Rollins, ? McPherson, ? Stewart, and John E. Leighton.

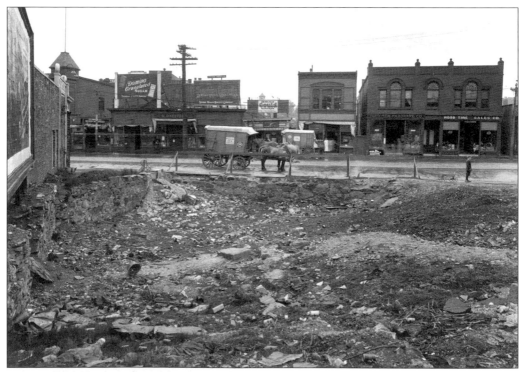

Ice carts like the one shown here were still a familiar scene on Mount Auburn Street in the 20th century. A 1933 business directory lists 10 ice companies serving Watertown customers, even though electricity was already common in most homes. The foreground shows the demolition of Beacon Square.

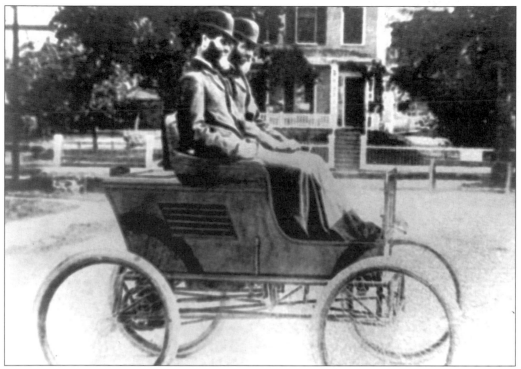

Sterling Elliott began manufacturing bicycles in Watertown in 1882. Many of his inventions, including inflatable rubber tires for bicycles and some for the quadricycle, were later used for automobiles. In 1896, Elliott sold his factory to Freelan O. and Francis E. Stanley. By 1897, the Stanley twins had produced their first steam-powered car, shown here. This same model was the first automobile to climb Mount Washington. The eight-mile trip took just over two hours.

James H. Sullivan ran Watertown's first gas station at 508 Main Street, at the corner of Rosedale Road. His business is listed in a Watertown business directory for 1923.

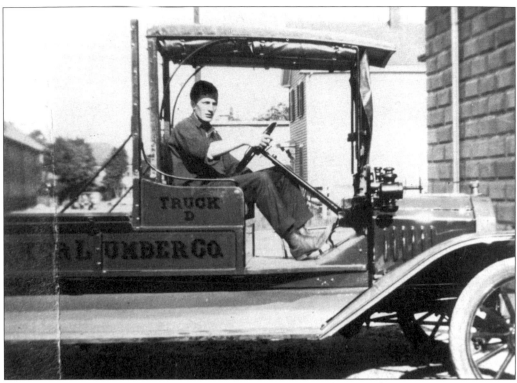

Watertown businesses and town departments have always had the best equipment. Thomas Cullen drove the company truck for Barker's Lumber in 1917. This Watertown Water Department vehicle probably dates from the 1920s.

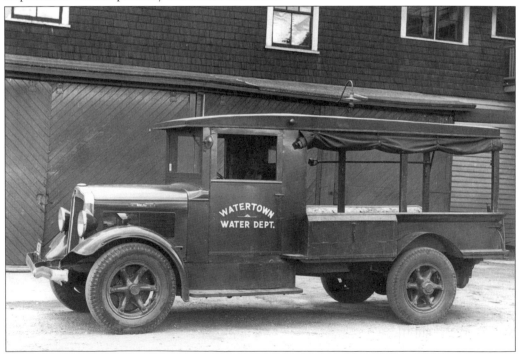

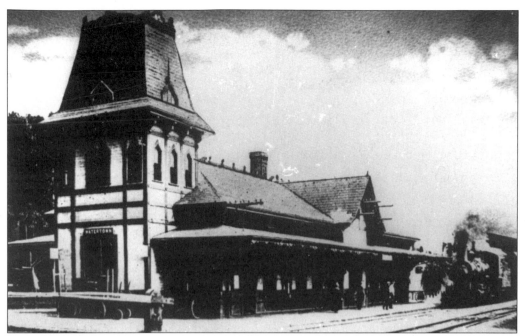

From the mid-1850s on, commercial railroad lines serviced westbound passengers through the Watertown Railway Station near Spring Street. This photograph was taken *c*. 1890.

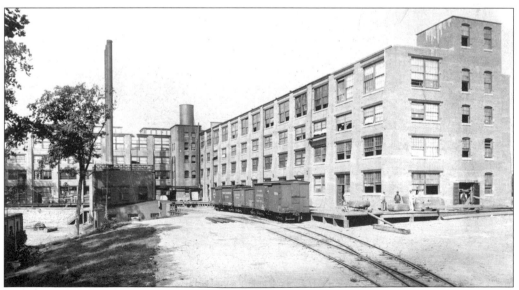

Various local industries such as the Hood Rubber Company, shown here *c*. 1900, and the Union Market stockyards relied on the railroads to move their goods.

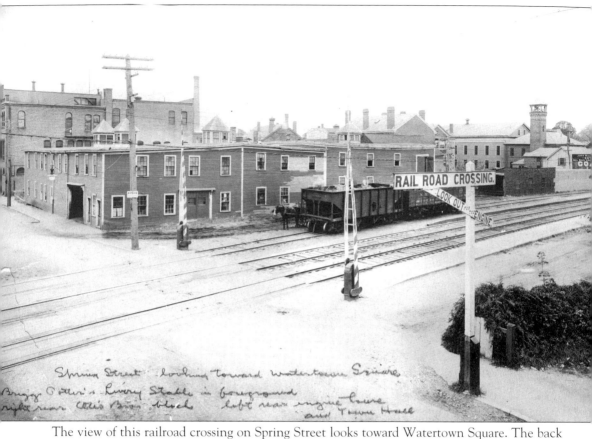

The view of this railroad crossing on Spring Street looks toward Watertown Square. The back of the old town hall can be seen at the rear left of this photograph.

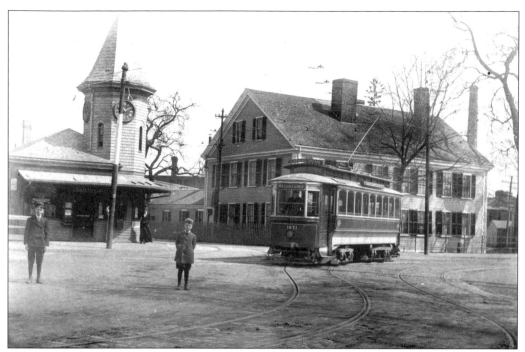

At the beginning of the 20th century, the Watertown Square Streetcar Station was erected as the popularity of the trolleys grew. Mount Auburn, Arsenal, Main, and Galen Streets were widened to accommodate the traffic. Fare was 5¢. The building behind the trolley is the Coolidge Tavern.

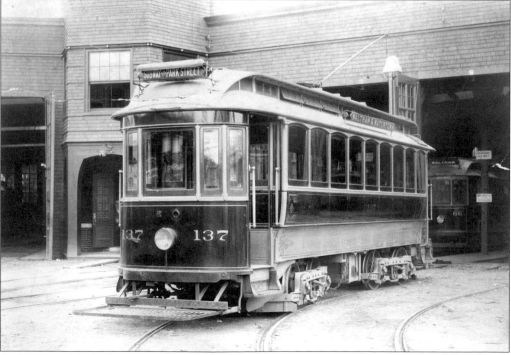

Built in 1902, this Boston Elevated Street Railway car was 33 feet long and carried 34 passengers. It is shown here in 1931 at the Waltham carbarn.

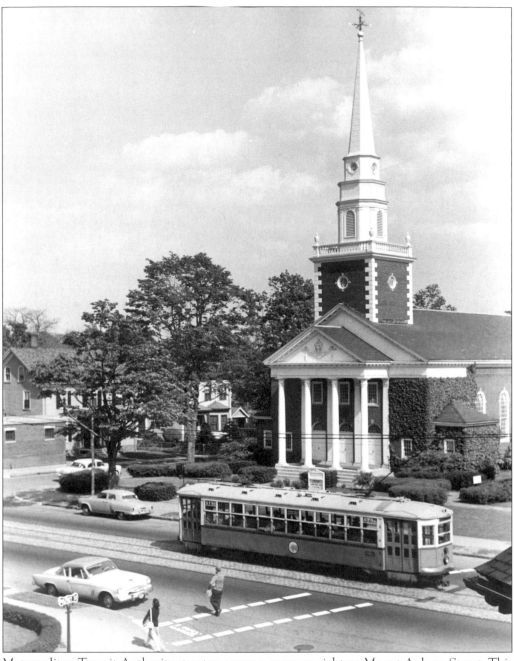

Metropolitan Transit Authority streetcars were a common sight on Mount Auburn Street. This photograph, taken in 1955, shows one in front of the Phillips church.

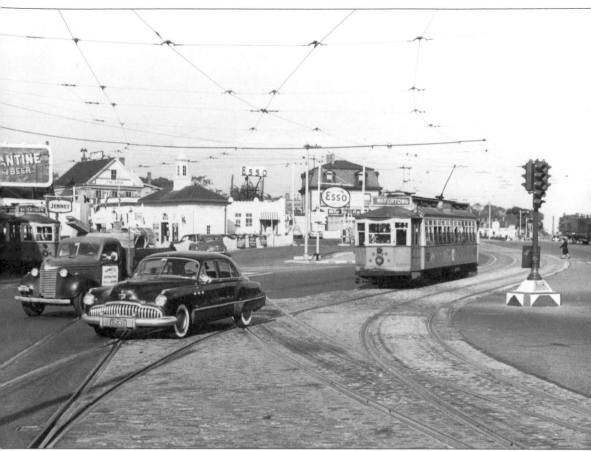

Tracks and automobiles used the same roads and traffic signals in Watertown Square in the late 1950s. In this photograph, Type 4 street cars from Harvard Square (left) and Central Square (right) arrive in Watertown Square.

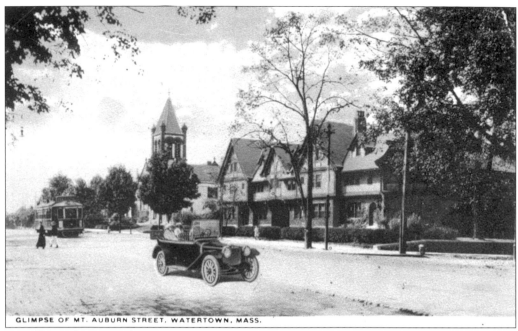

A trolley and car travel on Mount Auburn Street.

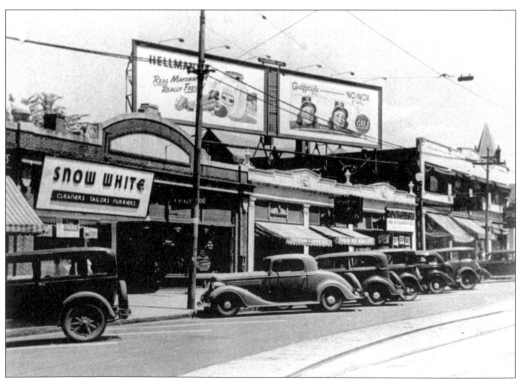

Years ago, cars were allowed to park at an angle in Watertown Square. Snow White Cleaners was one of many shops lining the first block of Mount Auburn Street. A billboard overhead proclaims the virtues of Hellman's mayonnaise.

Four
WATERTOWN SQUARE

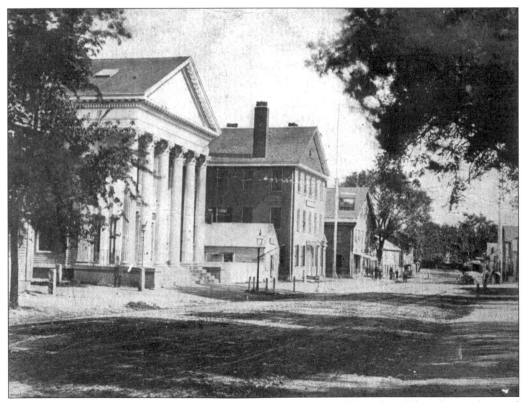

This view of Main Street, looking east, was taken in pre–Civil War days. The white columned building in the foreground is the old town hall, which later housed the library and the jail. It is separated from the Spring Hotel by a tiny building.

An old elm tree stood next to the building that housed McLauthlin's Bookstore. The space was also occupied by William Rogers, a watchmaker.

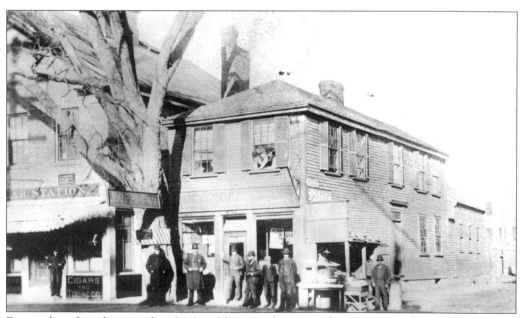

Featured in this photograph is McLauthlin's Bookstore, with its majestic elm and Joe Torres's peanut stand in front. It was a popular meeting place in the early days. William Rogers, watchmaker, also had a shop in the building.

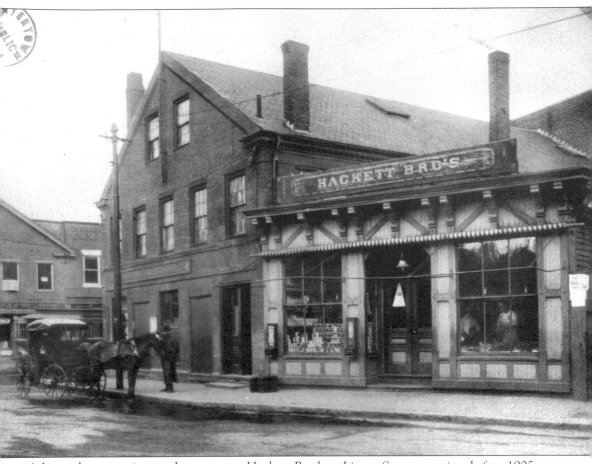

A horse-drawn carriage makes a stop at Hackett Brothers Liquor Store sometime before 1905. The store was demolished in the 1920s along with others in Beacon Square. Hackett Brothers moved to a Main Street storefront, where they did business for decades.

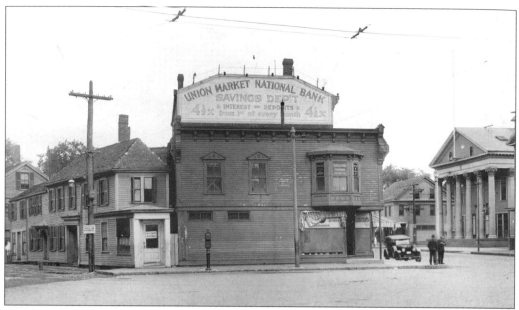

In 1920, when this photograph was taken, the Union Market National Bank did not have its own building in the square. However, it did have great visibility with this billboard, which proclaimed its "4½% interest [rate] on deposits from the first of every month." The old town hall can be seen directly across the street. A sign on a post near the building warns, "Speed Law Enforced."

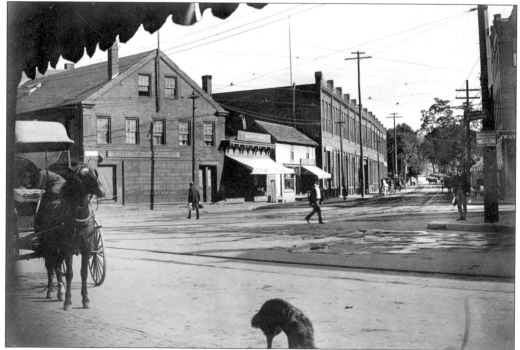

The Walker & Pratt Manufacturing Company occupied a prominent building on Galen Street in Watertown Square during the 1860s. To the right of Walker & Pratt's facility is the Lewando's building of the same vintage.

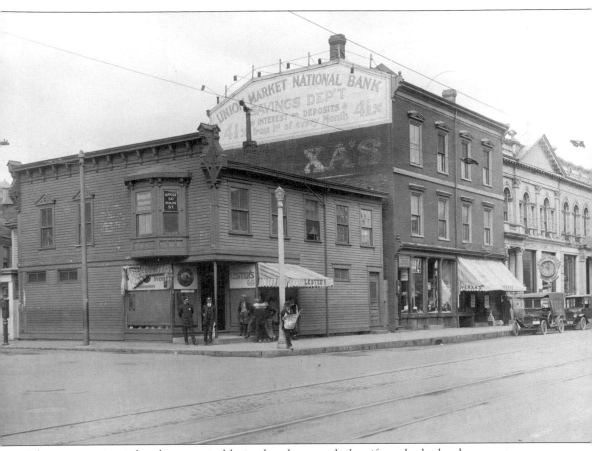

This intersection is barely recognizable in the photograph, but if you look closely, you can see the Watertown Savings Bank building at the far right. The building remains there today, although the clock has disappeared. Lester's was torn down to make way for a new, high-profile location for the new Union Market National Bank building.

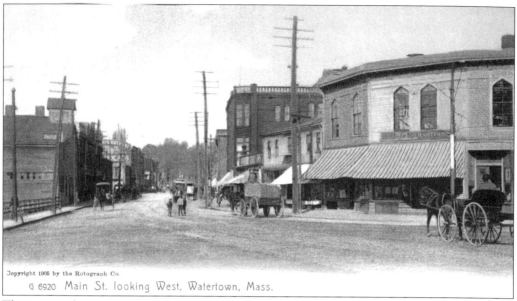

G 6920 Main St. looking West, Watertown, Mass.

This postcard gives a view of Watertown Square at the beginning of the 20th century. The horse and carriage still served as a primary means of transportation at that time. Here, travelers pass through the square on their way to points west.

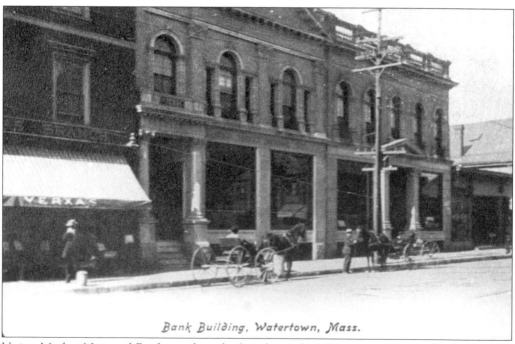

Bank Building, Watertown, Mass.

Union Market National Bank may have built it, but today, Watertown Savings Bank owns the beautiful limestone building that faces out to the square. At one time, the block was a bankers' row of sorts, with two additional banks—Watertown Cooperative and Watertown Federal Savings—based in the same block of Main Street.

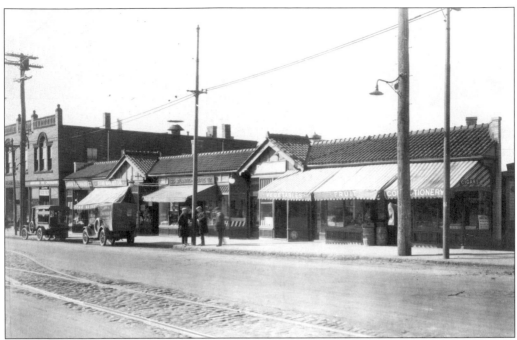

In the early 1900s, the first block of Mount Auburn Street included Star Market, Whitney's Confectionery, the Great Atlantic & Pacific Tea Company, and a fruit and vegetable stand.

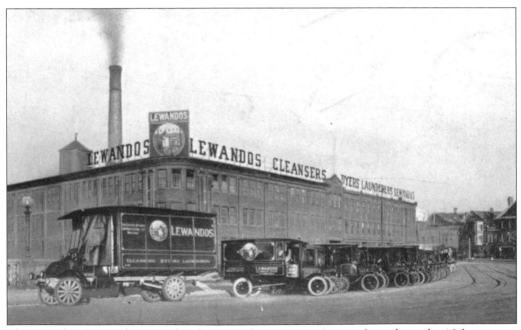

The sprawling Lewando's complex dominated Watertown Square throughout the 19th century. With an enormous fleet of horses and wagons and later company trucks, Lewando's became the largest cleaning and dyeing business in the United States, employing many immigrants and expanding across the region. After 150 years in Watertown, Lewando's moved its headquarters to Needham in 1969. The structure still stands today, serving as an office building.

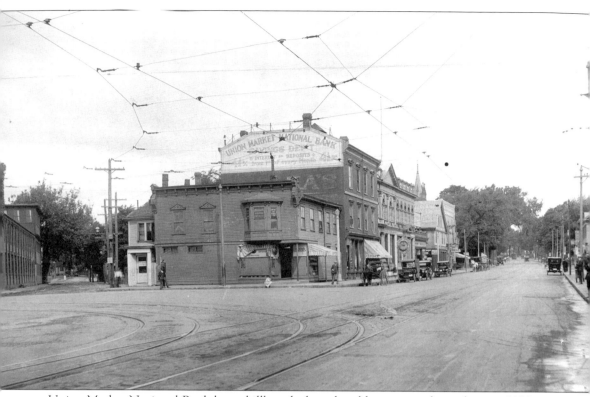

Union Market National Bank lost a billboard when the old structure, shown here in 1920, was torn down. A beautiful new building took its place. Trolley tracks are visible in the foreground of this photograph. Pleasant Street is on the left, and Main Street (also the Watertown segment of the Boston Post Road) is on the right.

At the end of the 19th century, a hodgepodge of buildings made up Beacon Square—the space between Galen and Main Streets. The Young Men's Assembly created a plan for the future of Watertown in 1898 that included eliminating Beacon Square, thereby allowing Mount Auburn Street traffic direct access to the Galen Street Bridge. In the 1920s, their goal was realized when the Metropolitan Park Commission demolished the buildings to make way for a street system and the present Delta.

Pictured here is the corner of Galen and Watertown Streets, with the old Pequossette Theatre on the right.

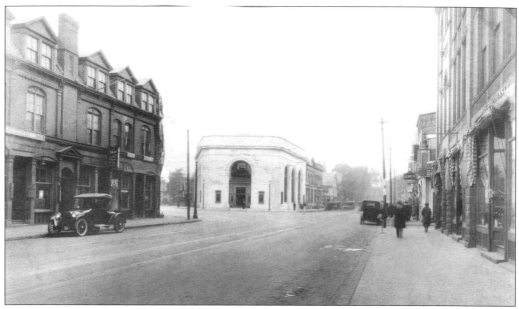

The new Union Market National Bank building gave Watertown Square the look of a prosperous town. To the right of the new bank building is Main Street, leading to Waltham. To its left is a block of ill-fated buildings, demolished later to make way for the parklike Delta that occupies that space today.

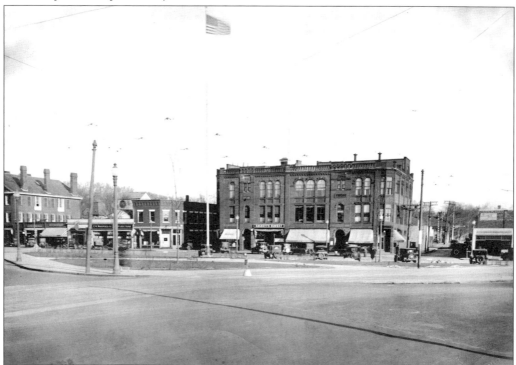

This view of Main Street looks out over the newly constructed Delta. The Spring Hotel is on the far left. The large building in the center of the photograph was occupied by the Otis Brothers store and other, smaller shops.

48

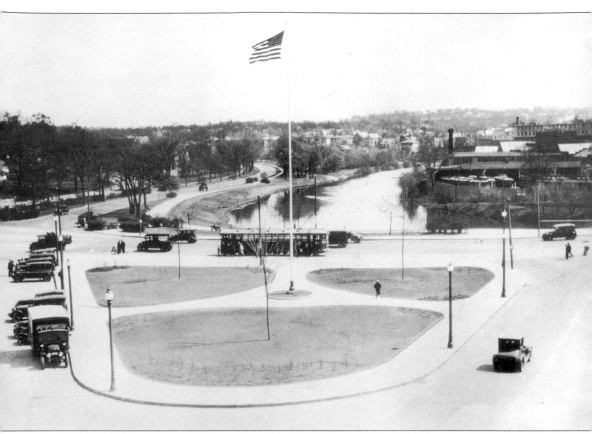

In May 1927, the Metropolitan District Commission agreed to transfer the title of the Delta to the town of Watertown. As part of the deal, the town agreed to allow the expansion of the Galen Street Bridge, but no structures were to be built in the center of the square, aside from the lone flagpole that remains today. The unsightly old chimney stacks of the former gas works were cleared away, and traffic lights were installed. The new, attractive Watertown Square was hailed by all as the flag was raised in a festive dedication ceremony.

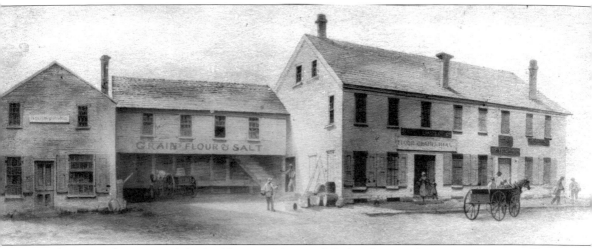

This is another view of the buildings at Main and Galen Streets, from an 1860 James Sharp drawing. Built in 1792, the buildings were owned by Abel Hunt, whose liquor store occupied the second floor. Other businesses here included Thomas Trull's fish market; Magee and Lindley's grocery; and J. Albert Sullivan's drugstore. A nearby shed was used to store grain and other supplies.

Five
BUSINESS AND INDUSTRY

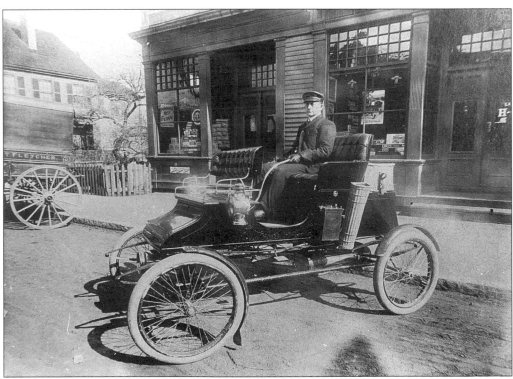

Irving T. Fletcher is the driver of this Stanley steamer parked at the corner of Pleasant and Bridge Streets. The Stanley brothers devised many improvements for the steamer and set a speed record in 1906. The gasoline engine marked the demise of the steamer, and by the beginning of World War I, fewer and fewer steamers were being manufactured. Freelan O. Stanley finally sold the business in 1925.

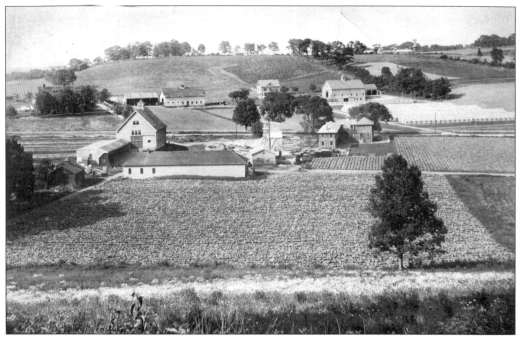

During the 19th century, Watertown was home to more than 100 fruit and vegetable farms, including Lovell Brothers Farm, seen in these two photographs. Apples, pears, cucumbers, and asparagus were just a few of the crops that flourished at Watertown farms—some into January. Beginning in 1920, farms were subdivided into lots to accommodate housing for the rapidly expanding population.

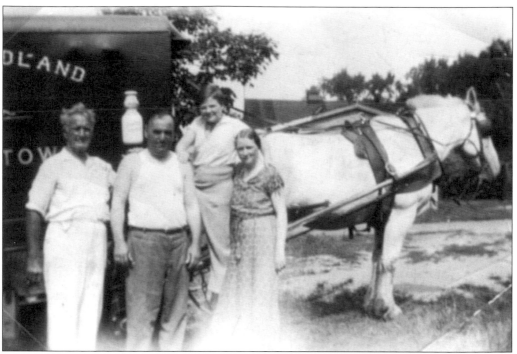

Founded by Charles Woodland in 1919, Woodland Dairy soon became the area's leading milk dealer, with a bottling plant on Waverley Avenue. In its heyday, Woodland Dairy's 55 trucks delivered 19,000 quarts of milk each day to customers in 16 communities. Neighborhood children also enjoyed the dairy's ice-cream shop. The Woodland Towers complex, home to senior citizens, now stands at the dairy's former location.

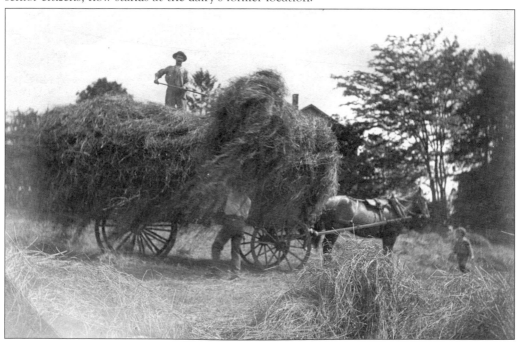

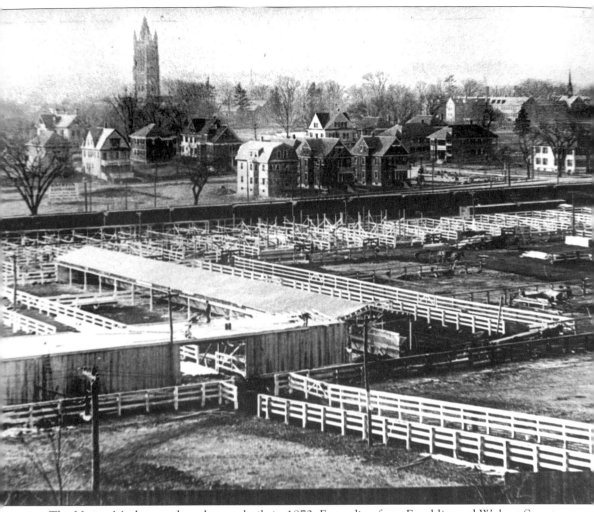

The Union Market stockyards were built in 1872. Extending from Franklin and Walnut Streets to the railroad tracks, the stockyards were a boon to Watertown commerce. Beef cattle from the West and from northern New England were unloaded here, and a cattle market took place each Tuesday morning. The animals were held in pens and later herded down Arsenal Street to the Brighton slaughterhouses. With the advent of refrigeration, temporary storage of beef cattle was no longer necessary. For a time, the stockyards were used to quarter horses and mules en route from Canada to France by way of Boston. As the local population grew, residents began to complain about the noise and the unsanitary conditions. By 1918, the stockyards were but a memory.

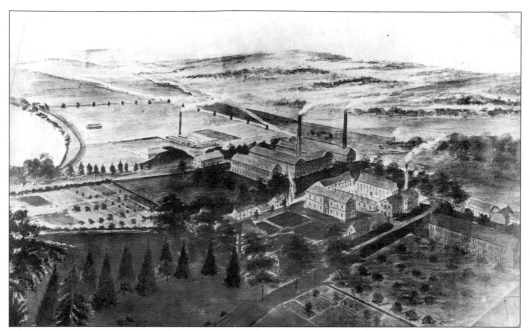

The Watertown Arsenal, commissioned by Pres. James Madison in 1816, was one of the first arsenals in the United States. This bird's-eye view dates from the Civil War.

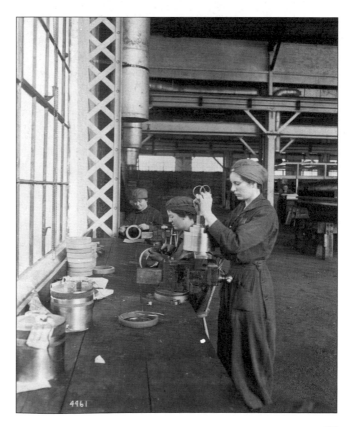

This undated photograph shows women working at the Watertown Arsenal.

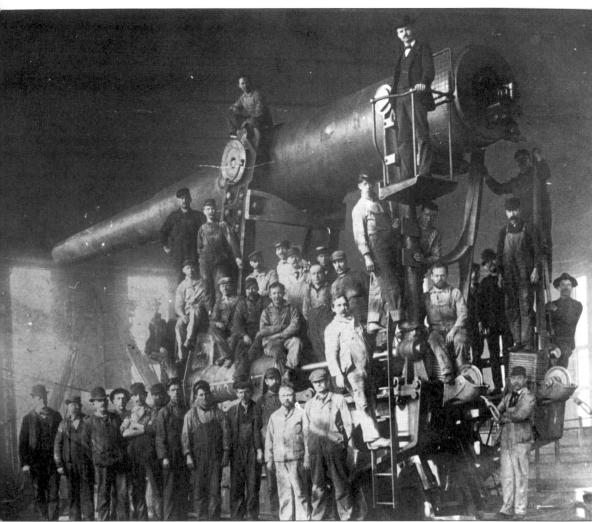

The site of the Watertown Arsenal was originally home to Native Americans. When a new arsenal was needed, Pres. James Madison selected the land because of its proximity to the Charles River. Capt. George Talcott oversaw the building of the first brick storehouse in 1816. Originally serving as a storage facility for gunpowder, it became headquarters for the cleaning, repair, and manufacturing of parts for small weapons. In the late 20th century, the Watertown Arsenal was sold to private real estate developers. Harvard University purchased 30 acres of the complex in 2000. Here, workers gather at the Watertown Arsenal c. 1900. Edward F. Burke (top right) was the father of Charles T. Burke, who authored several books on Watertown history and was a trustee of the public library for nearly 50 years.

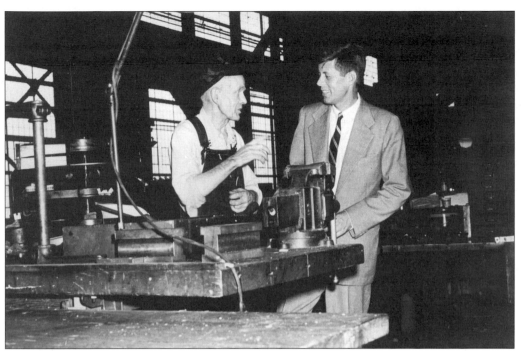

Rep. John F. Kennedy paid a visit to the Watertown Arsenal in 1952. Early in his career, Kennedy was a member of Watertown's Ancient Order of Hibernians.

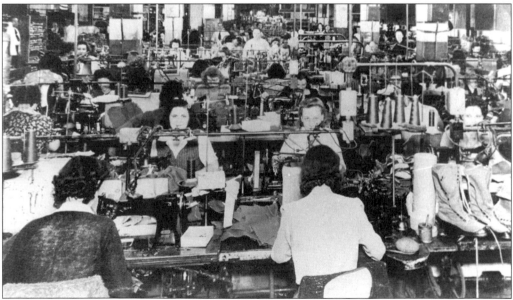

A local business organization known as the Young Men's Assembly scored a major success in 1896 when the group persuaded brothers Frederic and Arthur Hood to open a rubber plant in East Watertown. The plant soon became one of the town's biggest employers, providing more than 10 percent of its tax revenues. At the height of its success in 1920, the Hood Rubber Company employed 10,000 men and women, including many Armenian, Canadian, and eastern European immigrants. Initially a tire manufacturer, the Hood plant went on to produce aviation boots, rubber rafts, and many other supplies used in World War II.

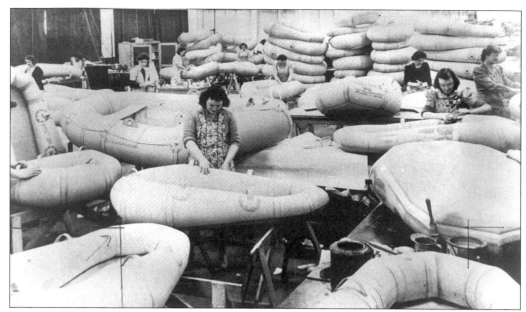

As part of the wartime effort on the home front, the women pictured here are making rafts during World War II, at the Hood Rubber plant.

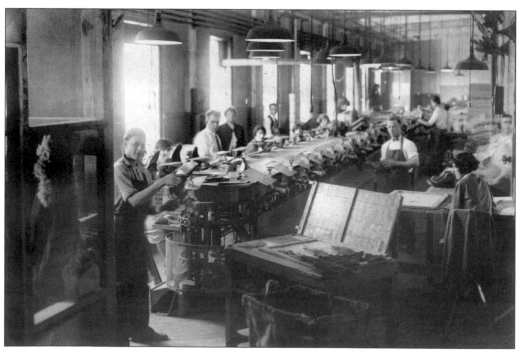

A shoe conveyor machine is put to use at the Hood Rubber Company's factory.

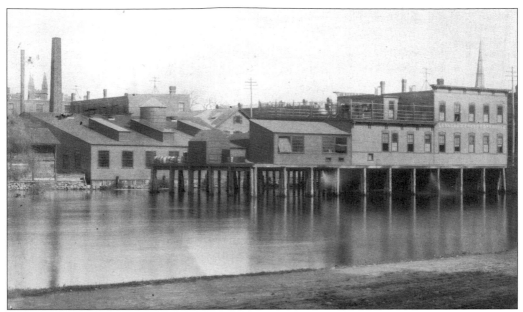

Pictured here is the Lewando's building, built in the early 1860s by Adolpho Lewando, who brought the revolutionary dry-cleaning concept with him from France. Within this large building, all types of household materials and personal garments were processed. A large fleet of trucks with uniformed drivers provided door-to-door pickup and delivery service throughout the area. The trucks could be recognized by a distinctive logo (created *c.* 1898) of a mother cat hanging her different colored dyed chicks on a clothesline.

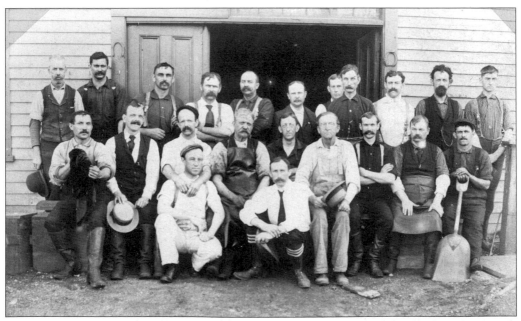

Workers in Lewando's dyeing department took time out of their workday for this photograph sometime before 1900.

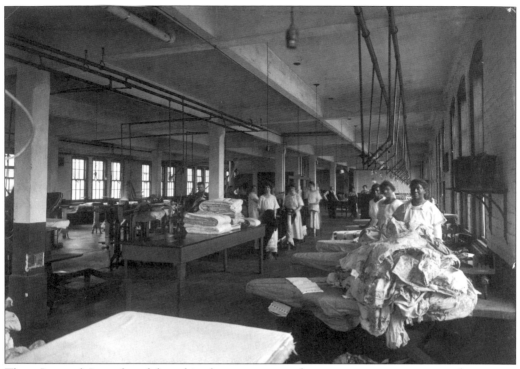

These Lewando's workers labored in the press room, where items were steam pressed.

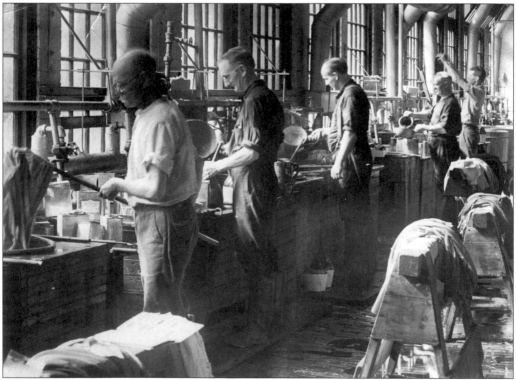

The men pictured here worked in Lewando's dyeing department *c.* the 1930s.

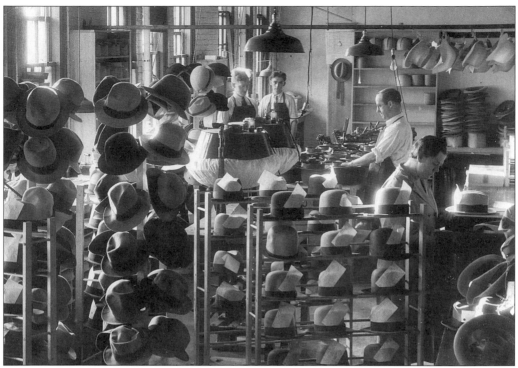

These Lewando's workers are preparing hats for cleaning *c*. the 1930s.

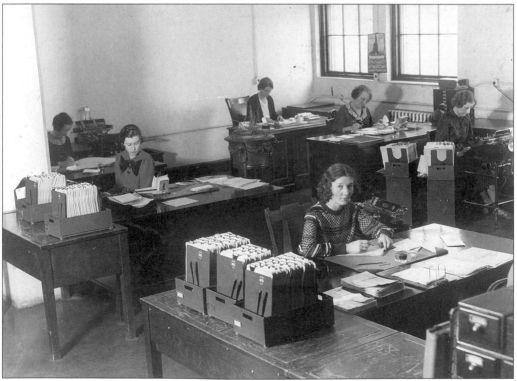

Lewando's had a large office staff. Some of the office workers are pictured here at their desks.

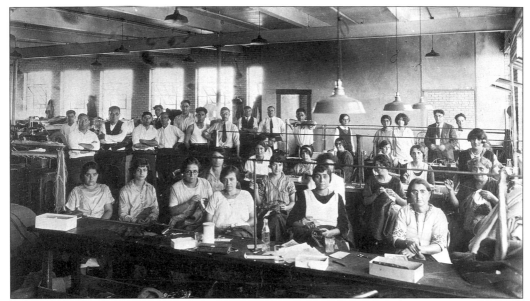

Stitchers, tailors, cutters, and foremen work at M.S. Kondazian & Sons men's clothing factory at 70–80 Coolidge Hill Road, in the mid-to-late 1920s. Built in 1924, the building is now home to Eastern Clothing. The photograph donor's grandmother, Hripsime Pistofjian Sinanian, appears in this image. (Project SAVE Armenian Photograph Archives; courtesy of Susan Lind-Sinanian, Watertown.)

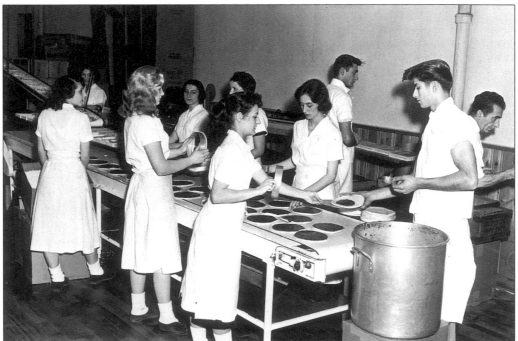

In this late-1950s view, assembly-line workers produce pizza at Euphrates Bakery on Dexter Avenue. Charles Mosesian, owner of the factory, created the first frozen pizza right here in Watertown. (Project SAVE Armenian Photograph Archives; courtesy of Charles Mosesian, Watertown; photograph by Ken Hird.)

A building of note that remains in Coolidge Square is the Town Diner. Since 1947, the sleek aqua and silver diner, highlighted by colorful neon signs, has graced the corner of Mount Auburn and Bigelow Streets. The diner was modernized in the 1960s, but it was not until Don Levy purchased the diner in August 2000 that it was restored to its original appearance and renamed the Deluxe Town Diner.

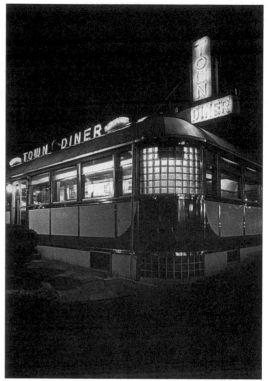

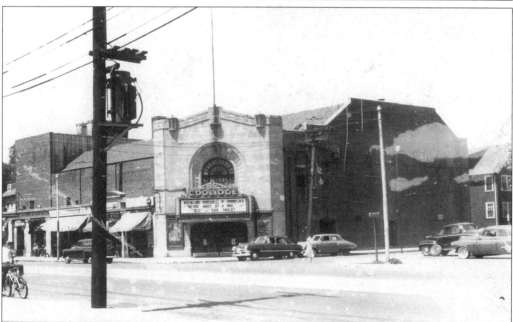

Coolidge Square was a completely different place 50 years ago. The Coolidge Theatre, located at the corner of Mount Auburn and Arlington Streets, played the big Hollywood movies until it closed in the 1950s. The building was demolished, and a convenience store took its place. Two popular bowling alleys on Mount Auburn Street also fell by the wayside. Across the street, an original stone building that once housed the Coolidge Bank managed to survive.

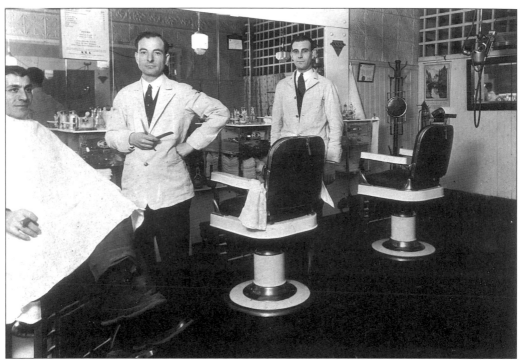

Two barbers at 600 Mount Auburn Street, in the heart of Coolidge Square, stand ready to serve Watertown residents in need of a haircut or a shave *c.* 1934. (Project SAVE Armenian Photograph Archives; courtesy of Ann Nahabedian, Durham, North Carolina.)

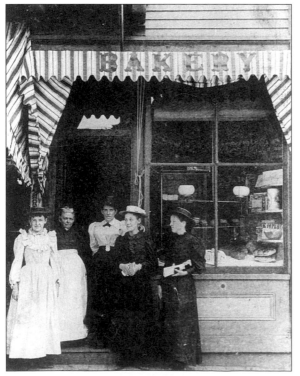

Harrison's Bakery, at the corner of Main and Church Streets, served as a gathering place in the early 20th century. Pictured in front of the store in 1900, this congenial group includes Alice Cox Phipps, Grandmother Harrison, and Abbie May Harrison.

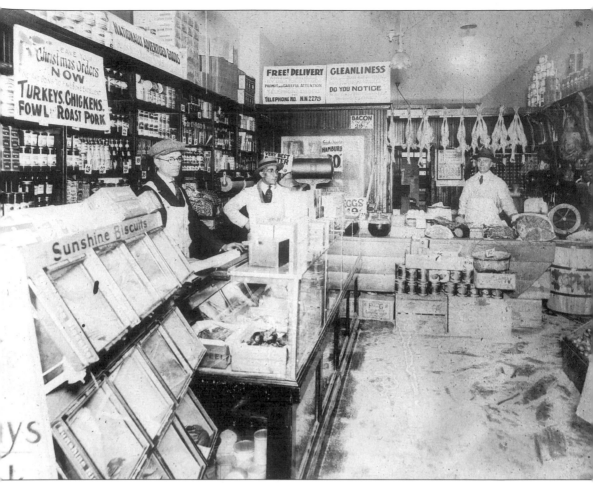

This early Star Market on Mount Auburn Street is fully stocked for the holiday season of 1921. The Mugar family, who owned a restaurant in Boston, purchased the store in 1916.

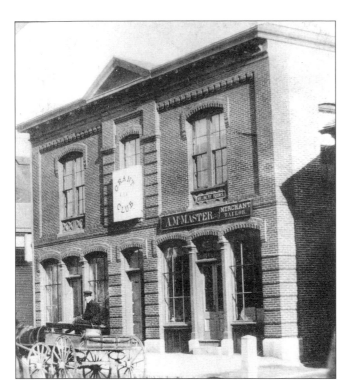

Central Hall was built by A. McMaster, whose tailor shop occupied the right side of the building. A sign on the second floor reads, "Grant Club." Built in 1872, the building was demolished in 1913.

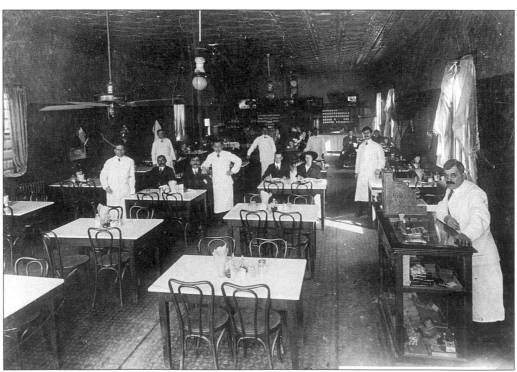

Waiters stand ready to serve at this restaurant, located at 76 Bigelow Avenue, in 1915.

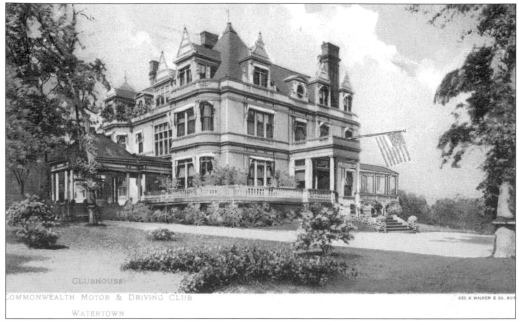

The restaurant at the Commonwealth Motor and Driving Club was the site of much frivolity in the early 20th century, when Watertown was a dry town. The club was one of a handful of drinking and gambling clubs that catered to the wealthy motoring set. Eventually, the Commonwealth Club was raided by the police. It was eventually closed down and its license revoked. The building burned to the ground in the winter of 1911.

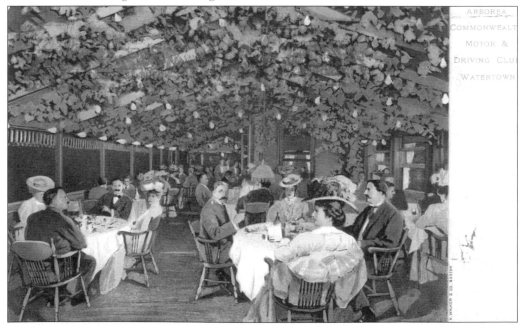

The Commonwealth Motor and Driving Club occupied the spectacular Warner mansion at the corner of Belmont and School Streets. In its heyday, the club was a showplace, resplendent with mahogany paneling, hand-carved furniture, and Italian frescoes on the ceilings. A portrait of a nude hung behind the bar.

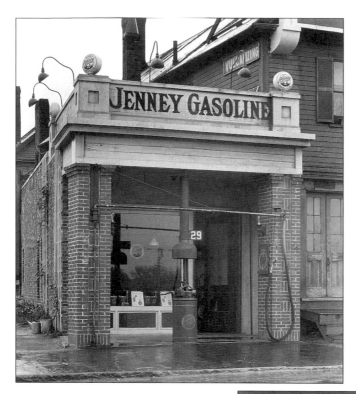

The Jenney Gasoline station was a landmark in Watertown Square. A 1933 Watertown business directory lists 42 garages and automobile repair and supply firms.

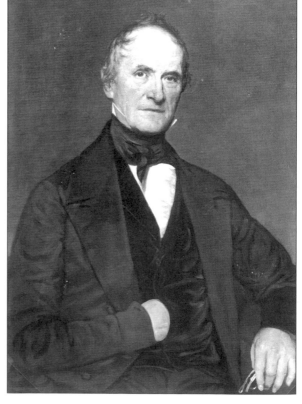

Seth Bemis (1775–1852) owned Bemis Mills, which manufactured cotton cloth, dyestuffs, and (later) fine woolen cloth. New sails for the USS *Constitution* were also woven here. The Bemis Mills complex, located on Bridge Street, included its own railway station. A knitting mill stood nearby.

Six

PEOPLE

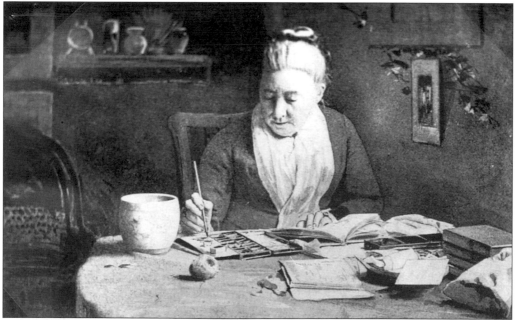

Ellen Robbins (1828–1905) lived on Pleasant Street facing the Charles River. She became a well-known watercolorist specializing in paintings of natural subjects, particularly of flowers and fruit. Robbins also painted on china, a widespread practice in the 19th century. She later moved to Boston, where she taught art and had three studios. Robbins was a cousin of Maria White Lowell.

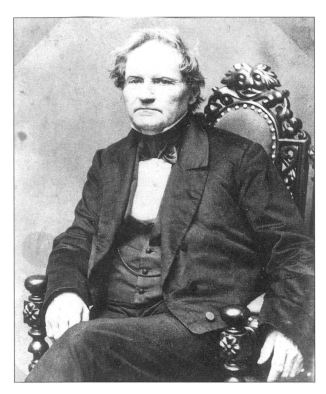

This portrait of Rev. Convers Francis (1795–1863) is in the Watertown Free Public Library. Francis, a Unitarian, was minister of the First Parish Church from 1819 to 1842. Before coming to Watertown, he preached in Medford and Salem. Francis wrote *A Bicentenary History of Watertown* in his home at the corner of Riverside and North Beacon Streets. In 1842, he became a professor of theology at Harvard Divinity School.

Lydia Maria Francis Child moved to Watertown in 1822 to reside with her brother, Rev. Convers Francis, and his wife at the parsonage on the corner of Riverside and North Beacon Street. Here she wrote *Hobomok*, the first historical novel of New England. She continued to write and to teach school until she moved from town with her husband, David Lee Child, in 1828.

Maria White Lowell was active in the abolitionist and temperance movements. Her husband, poet James Russell Lowell, referred to her as "a glorious girl with spirit eyes." She received a parcel of land as a wedding gift from her father, which was later given to the town. On it now stands the Lowell School and the North Branch of the Watertown Free Public Library.

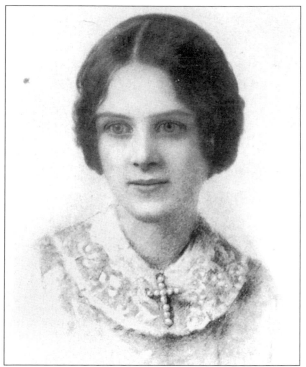

This young lady, Mabel Lowell, is all decked out in her finery, but she does not seem to be too happy about it.

Solon Whitney (1831–1917) was the first librarian of the Watertown Free Public Library, a position he held from 1868 until 1917. He was also the librarian for the Historical Society of Watertown, principal of the high school and caretaker of the high school building. Whitney collected the papers presented to the historical society by its members and published them in a book called *Historical Sketches of Watertown*.

Josiah Stickney (1789–1876) made a fortune in the sugar, railroad, and whaling trades. He purchased property from Benjamin Faneuil Hunt *c*. 1830. It included 34 acres and a Georgian home with a view of the Charles River. Stickney became a prominent figure in the business community, holding numerous board positions with banks and railroads. In the late 1800s, Edward Allen, seeking a site for what was to become the Perkins School for the Blind, bought the property.

Anne Whitney (1821–1915), a descendant of Watertown settlers, was born on Galen Street. As a young girl, she studied anatomy and practiced drawing from life. In 1867, she went to Rome, where she perfected her sculpting, and remained there for four years. After her return to Boston, Whitney entered a sculpture contest to honor the memory of Sen. Charles Sumner, a famous abolitionist. Her design, submitted anonymously, won the contest. Upon learning that the winner was a woman, the judges refused to grant her the commission. Years later, a group of her friends commissioned the work. Her bronze statue of Senator Sumner now stands in Harvard Square. A plaster model of this work is located in the Watertown Free Public Library. Other public art by Whitney in the city of Boston includes statues of Leif Ericson, on Commonwealth Avenue near Kenmore Square, and of Samuel Adams, in front of Faneuil Hall.

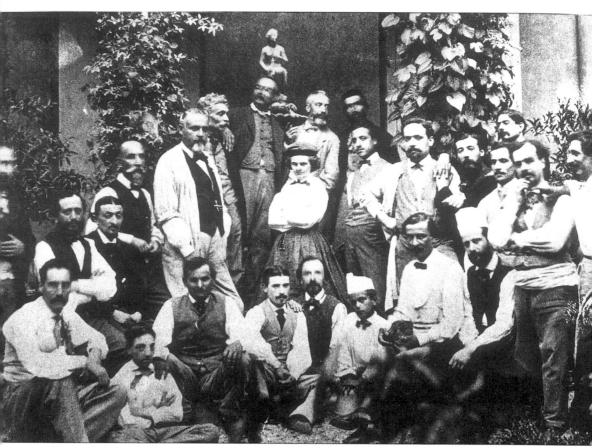

Harriet Hosmer (1830–1908) grew up on the banks of the Charles River in Watertown Square. As a young girl, she was intent on pursuing a career in sculpture. Her attempts to enroll in anatomy lectures at Boston Medical Academy were rebuffed, as it was unheard of for females to attend such classes. Wayman Crow, an influential businessman, arranged for her to observe classes at the Medical College of St. Louis. After studying anatomy, she perfected her artistic talent in Rome, where she lived most of her adult life. She became one of the most famous American sculptors of her time, favoring the neoclassical style. Her most popular work is *Puck* (1856), of which she made many copies, a sculpture inspired by the character in Shakespeare's *A Midsummer Night's Dream*. The Watertown Free Public Library holds the largest collection of Hosmer's works in the world. Her work is also exhibited in the Boston Museum of Fine Arts and the Boston Athenaeum. She is shown here with her workmen in her studio in Rome.

Mercy Otis Warren (1728–1814), married to James Warren, president of the Provincial Congress, was a notable person in her own right. Dedicated to the American cause, she wrote patriotic poetry, songs, and plays. In 1805, she wrote a three-volume book entitled *History of the Revolutionary War*. Many letters exchanged between Warren and her good friend Abigail Adams are archived at the Massachusetts Historical Society in Boston.

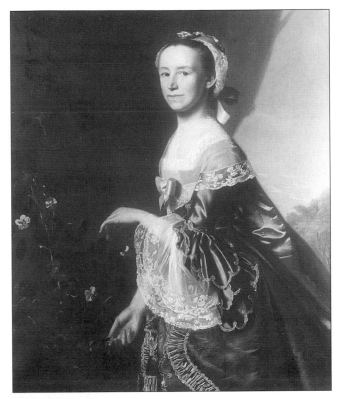

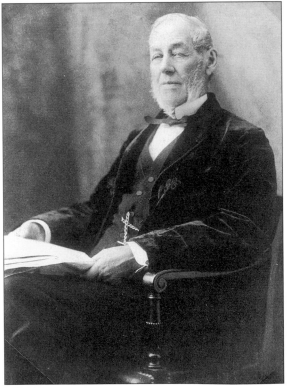

Horatio Hollis Hunnewell, a wealthy banker, was the son of Dr. Walter Hunnewell, for many years Watertown's only physician. In the 1880s, when the trustees of the public library needed money for a new building, Hunnewell donated $10,000 in memory of his father. Later, he donated more funds for an addition that is now known as the Hunnewell Room. Hunnewell is best known for his association with the town of Wellesley, which was named for his estate.

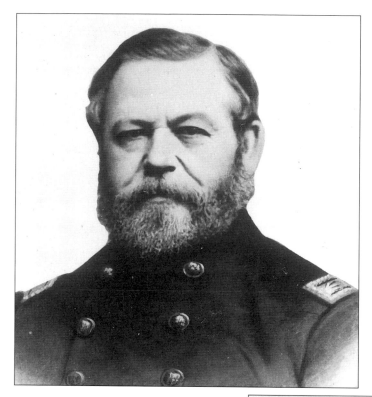

Thomas J. Rodman was the commanding officer of the Watertown Arsenal from 1859 to 1865. He established the first foundry and laboratory for testing the strengths of materials, the Emery Tester, which is now in the Smithsonian Institution. He also developed the Rodman Casting Process, which enhanced the metal structure and increased the life of the cannon. Many of these Rodman cannons, used during the Civil War, can be seen at Fort McHenry in Baltimore.

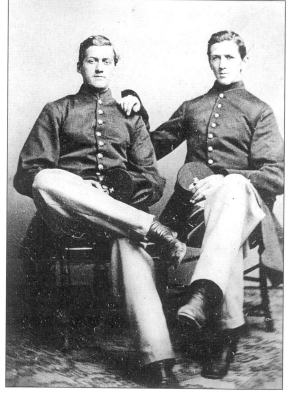

The Otis Building, which stands in the second block of buildings on Main Street in Watertown Square, is named after the brothers pictured here, Ward and Horace Otis. The brothers joined the 5th Massachusetts Infantry in 1862, serving nine months in the Civil War. Shortly after returning from the war, the brothers bought out Wheeler and Crane dry goods dealers, changing the name of the business to Otis Brothers. Their business flourished, and they eventually added another location in Newton.

Following the Civil War, Joshua Coolidge (1813–1908) joined with Charles Barry and Nathaniel Whiting to found the Watertown Savings Bank. In 1868, he was elected one of 10 trustees of the newly founded Watertown Free Public Library.

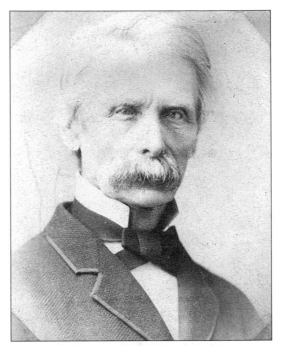

Rosamund Coolidge (center), daughter of library trustee Joshua Coolidge, studied at the Massachusetts College of Art and the School of the Museum of Fine Arts. She became a distinguished painter of portraits, winning awards at many exhibitions, including some sponsored by the Jordan Marsh Company and the prestigious Copley Society. Coolidge's subjects included Robert Frost, Samuel Eliot, and Rev. Convers Francis.

Charles Pratt (1830–1891) made a fortune in oil through his partnership with John D. Rockefeller. He founded the Pratt Institute in Brooklyn, New York, in 1887. In addition, he created a periodicals trust fund in honor of his father, Asa, at the Watertown Free Public Library. A room at the library is named in his honor.

Cofounder of the Walker & Pratt foundry, Miles Pratt (1825–1882) was a philanthropist who was active in the fundraising drive that resulted in the building of Watertown's public library. His foundry manufactured the Crawford stove and cannonballs for the Civil War. This photograph was taken in 1875.

Henry Fowle Durant (1822–1881), a successful lawyer, was keenly interested in the education of women. After the death of their two children, Henry and his wife, Pauline, were determined to found a college for women. The Durants bought land adjacent to the Hunnewell estate in Wellesley and donated their book collection for its library. The new Wellesley College opened in 1875. Durant is quoted as saying, "Women can do the work. I give them the chance."

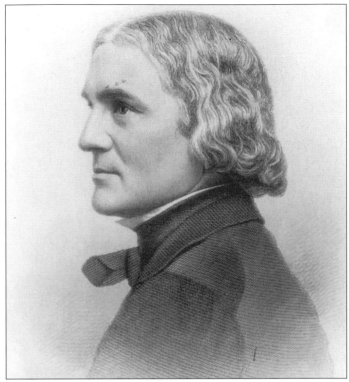

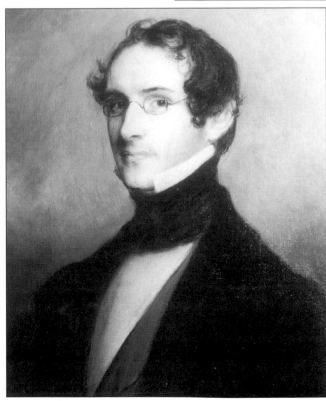

George Bemis (1816–1878), the brother of Bemis Mills owner Seth Bemis Jr., was a successful Boston lawyer. He founded the Chair of International Law at Harvard Law School.

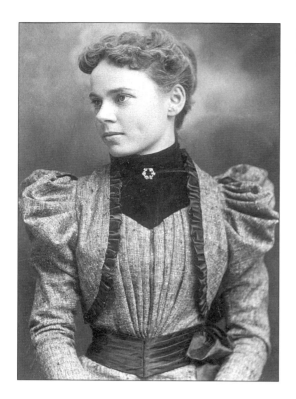

M. Agnes Burke, a schoolteacher who was active in town affairs, was the first auditor of the Watertown Women's Club.

In 1847, the Bemis Mills became Aetna Mills. Later, A.O. Davidson moved to Watertown to become general manager. Previously a manufacturer of cotton, Aetna Mills switched to producing fine woolen cloth. Business thrived until 1931, when it moved to Lowell. Today, Boston Scientific occupies the space. The name "Aetna Mills," carved in stone, remains as a reminder of the history of the building at the corner of Pleasant and Bridge Streets.

A businessman and inventor, Sterling Elliott (1852–1922) started his career by opening a bicycle shop on Maple Street, where he created the first quadricycle. He went on to invent a number of useful items, such as electric door openers, machine tools, and the Elliott steering knuckle, which was used on all automobiles for many years. His contribution to big business at the time was the Elliott addressing machine, which made him a very wealthy man.

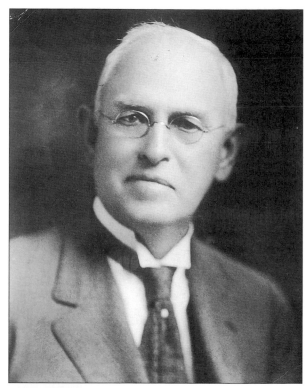

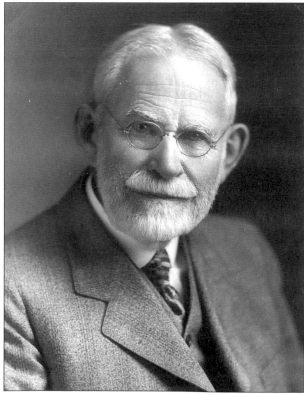

Born in Watertown in 1846, Charles Tainter participated in the invention of the graphophone, Dictaphone, and the radiophone. Through his development of a hard flat wax disk record, Tainter made the first phonograph commercially viable. Tainter spent the last 35 years of his life in San Diego, where he died in 1940. According to his obituary in the *Los Angeles Times*, Tainter was considered "the last of the great triumvirate of 19th-century American inventive geniuses, which included Alexander Graham Bell and Thomas Alva Edison."

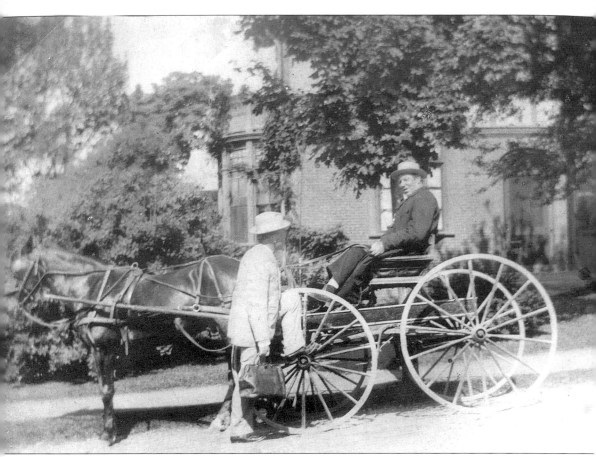

Architect Charles Brigham (1841–1925) was born in the Coolidge Tavern. Brigham is shown here with Tom Gavin in front of his house on Garfield Street. He played an active role in the town, including service on the board of library trustees, the school committee, and the historical society. He was a selectman, one of the founders of the Union Market National Bank, and the designer of the town seal, which depicts Roger Clap exchanging a biscuit for a bass with the local Native Americans. He designed many buildings in Boston, Newport, and Watertown, including the Francis School and the former East Junior High School on Mount Auburn Street. Brigham is credited for the design of Boston's old Museum of Fine Arts building, the Church of the Advent on Brimmer Street in Boston, an extension to the Massachusetts state capitol, the addition to the Maine state capitol building, and the extension to the First Church of Christ, Scientist in Boston. He was also responsible for moving the Edmund Fowle House to its present location on Marshall Street and for designing several houses on Garfield Street.

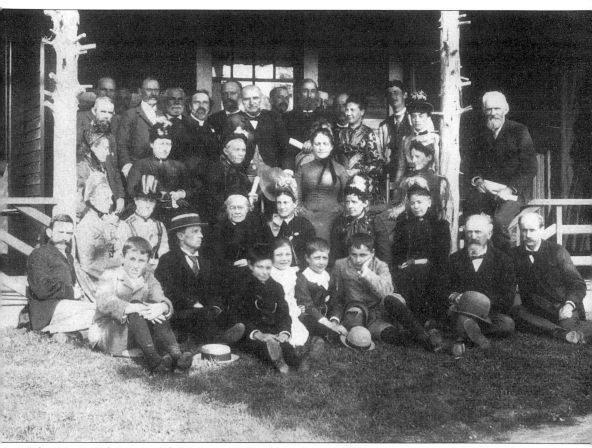

The Historical Society of Watertown was formed in 1888 by Dr. Alfred Hosmer (cousin to Watertown's famous sculptor, Harriet Hosmer), Rev. Edward Rand, and librarian Solon Whitney. The society promotes the study and preservation of historic events, subjects, and individuals in Watertown. The first meetings were held in the various members' homes, where essays, researched and written by the members, were read to the group. These essays were preserved by Rand and saved by the historical society. This photograph was taken in 1890 during a society-sponsored field trip to Weston, led by Prof. Eben Horsford, to see historic sights along the way, including Norumbega Tower. Horsford had the tower built to commemorate the landing of the Norse, who he believed had visited and built a city on the Charles River some 400 or 500 years before Columbus landed. The group traveled by a barge driven by four horses and stopped for lunch here, at the home of Andrew Fiske. They adjourned to the porch and had this photograph taken. Solon Whitney can be seen in the upper right-hand corner.

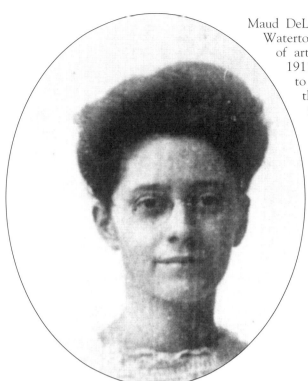

Maud DeLeigh Hodges (1888–1972) moved to Watertown in 1899. She earned her bachelor of arts degree from Boston University in 1911 and taught in Watertown from 1915 to 1919. She later worked as a reporter for the *Watertown Sun*, where she became interested in town affairs. *Crossroads on the Charles*, a history of Watertown, was based on her manuscript *The Story of Our Watertown*, which she completed in 1956.

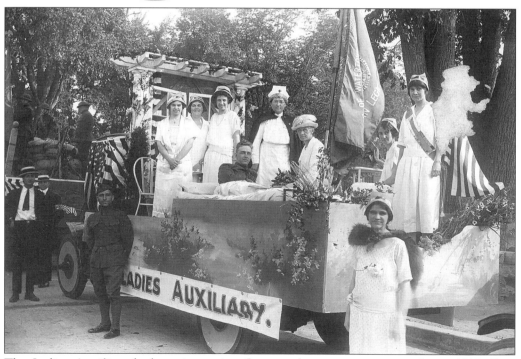

The Ladies Auxiliary had an impressive float at the tercentenary parade in 1930. Rita (Loughlin) Scudder—whose mother, Catherine Loughlin, sits on the float (second from right, next to flag)—provided this photograph.

Seven

HISTORIC HOUSES

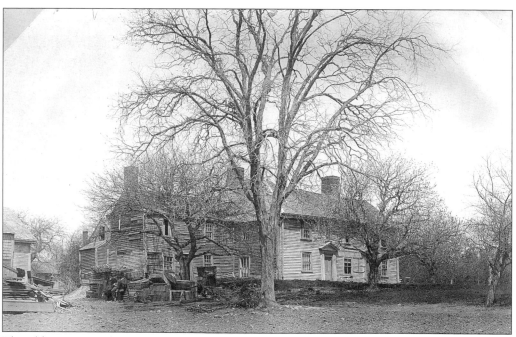

The oldest existing house in Watertown was built by Abraham Browne *c.* 1698 and is located at 562 Main Street. It was occupied by his descendants until 1900 and restored in 1924 by the Society for the Preservation of New England Antiquities. This structure shows fine examples of original 17th-century diamond-paned windows, huge hand-hewn beams, and a fireplace large enough to stand in.

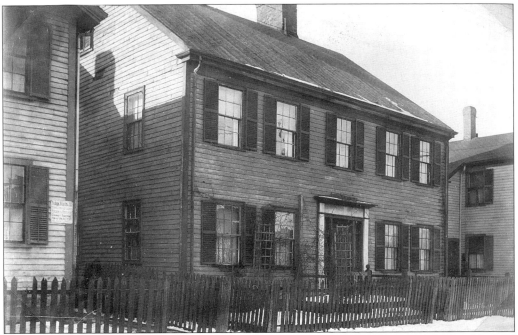

Originally on Galen Street and relocated to Water Street, this house was built by James Barton in 1715 and sold to John Hunt in 1745. Dr. Joseph Warren boarded here when he was president of the Provincial Congress in 1775. The house was later owned by Nathaniel Whitney Jr. Sculptor Anne Whitney was born here on September 2, 1821.

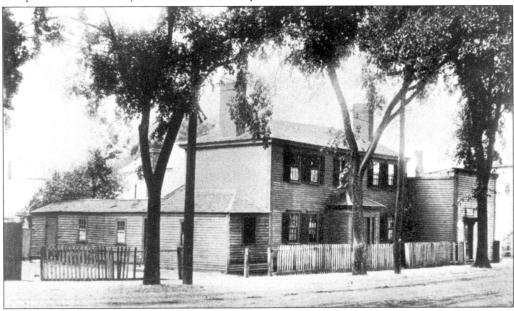

After the start of the Revolutionary War, Paul Revere moved to Watertown for safety. He lived in John Cooke's house for a year and printed Colonial money. Benjamin Edes was also a refugee in this house, where he continued to publish his newspaper the *Boston Gazette*. Gen. Joseph Warren and Elbridge Gerry, from the Committee of Safety, were frequent visitors. A marker at the intersection of Galen and Watertown Streets commemorates this site.

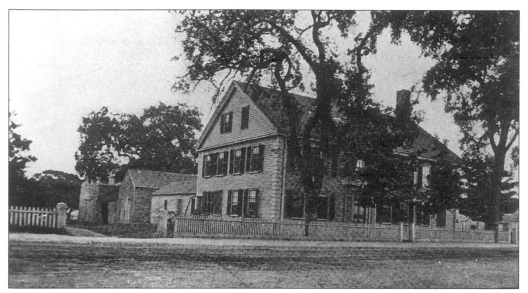

Ma'am Coolidge's Tavern was built c. 1740 at the corner of Galen and Watertown Streets. Gen. George Washington ate here on July 2 and November 5, 1775. British soldiers frequented this tavern before the Revolutionary War, as did members of the Massachusetts Provincial Congress between 1775 and 1776. The building was demolished in 1918 to make way for the Boston Elevated Street Railway's carbarns.

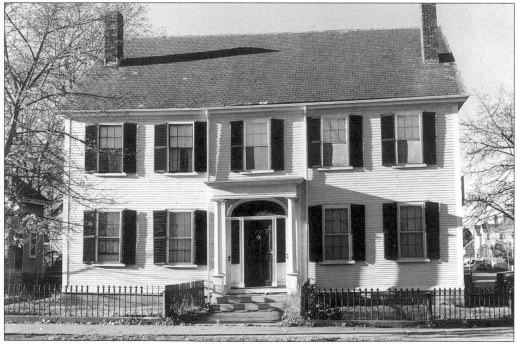

Levi Lincoln Thaxter, a clergyman and schoolteacher, lived in this house, now located at the corner of Main and Cuba Streets. Built c. 1815, the Thaxter house was originally located in what is now Saltonstall Park, on the site of the present Watertown Administration Building. It was moved to its present location in 1882. The house became a scholarly meeting place and was often visited by young Cambridge professors. Thaxter was married to writer and poet Celia Thaxter.

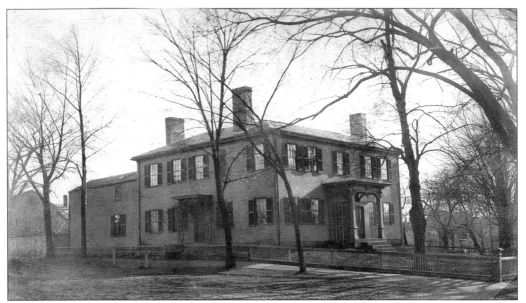

This house, which still stands at 6 Riverside Street, was the home of Rev. Convers Francis, minister of the First Parish Church from 1819 until 1842. In 1830, Francis wrote *An Historical Sketch of Watertown* in the study of this house. The house—which still has its old window casings with inside shutters and original staircase and fireplaces—is now occupied by the MacDonald, Rockwell, and MacDonald Funeral Service.

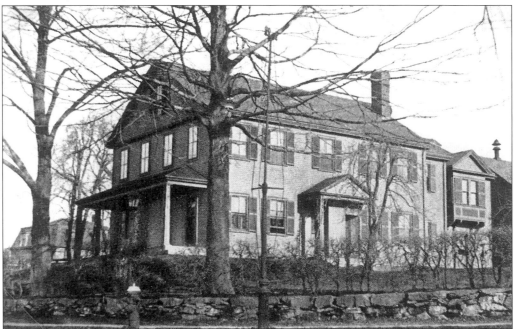

Harriet Hosmer, the famous neoclassical sculptor, was born in this house, next door to Convers Francis's house near the Charles River in Watertown Square. This house had a balcony, carved mantels, and a large kitchen. Each bedroom had an arched lavatory. Bellpulls to call servants were a sign of prosperity, and the copper bathtub was a luxury. The house was torn down and replaced by an apartment building in 1960.

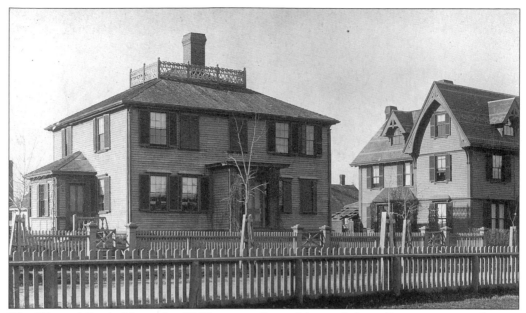

The Edmund Fowle House (*c.* 1742), originally on Mount Auburn Street, was moved to its present location on Marshall Street in 1872. The Council of the Provincial Congress met in a chamber on the second floor during 1775–1776. Many historical figures met here, including John Hancock, Robert Treat Paine, James Otis, Samuel Adams, John Adams and James Bowdoin. It has been owned by the historical society since 1922.

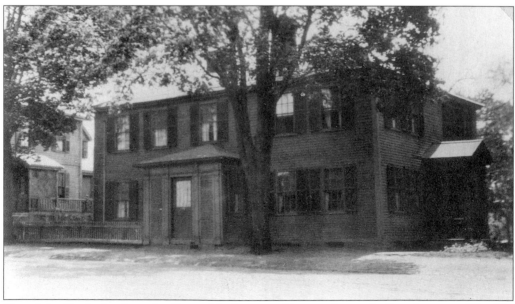

Capt. John Fowle fought under General Lafayette in Virginia during the Revolutionary War. His house, located at 49 Mount Auburn Street, for many years housed the offices of the *Watertown Press*. The house was razed in May 1967. Some of its doors and hardware were saved by Martin Tomassian, president of the Historical Society of Watertown at the time, for future use.

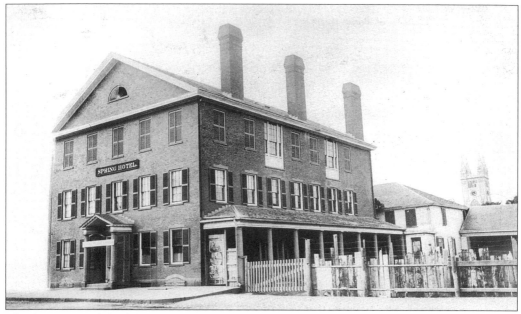

The Spring Hotel, built by Luke Robinson in 1822 on Main Street, was located across from the train depot. Volunteers training for service during the Civil War were provided three meals a day here by then owner Samuel Batchelder. Citizens who were unhappy with its alcohol sales forced the closing of the hotel in 1880.

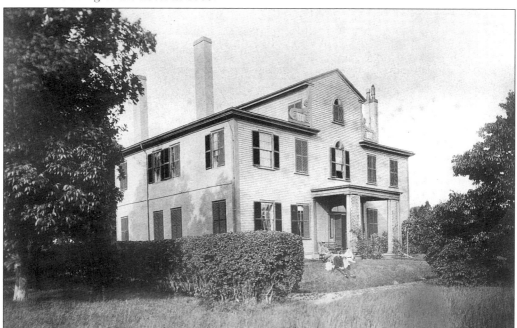

This 34-acre estate overlooking the Charles River was built by William Hunt and bought in 1845 by Josiah Stickney. Stickney made his fortune in the whaling, sugar, and railroad businesses. The property was eventually sold by the Stickney heirs and, in 1912, became the new site of the Perkins School for the Blind. The steep bank leading up to the property was also the site of explorer Roger Clap's landing in 1630.

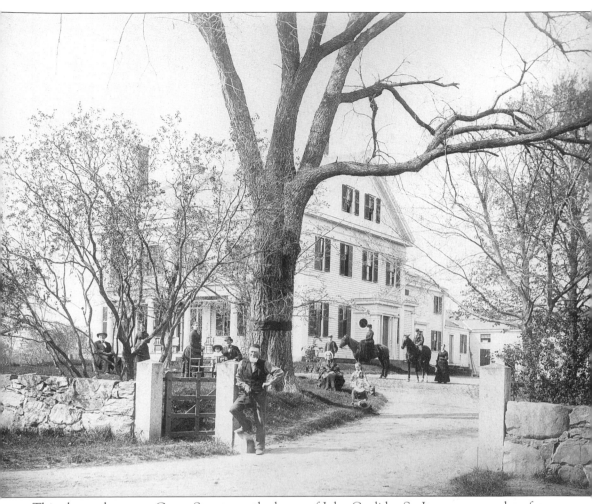

This elegant house on Grove Street was the home of John Coolidge Sr. It was very modern for its time, and although it had central heating for the first floor, there was no plumbing. A copper pump in the kitchen had to be thawed out in cold weather to pump up rainwater, which collected in a cistern. Pictured from left to right are Charles Davenport, Emma J. Davenport, Annie E. Davenport, Grace Coolidge, John Coolidge Jr., Pat White (standing at front gate), Mrs. John Coolidge Sr. (Mary Stone Bond), Charles Davenport (standing near house), Alice and Mary Davenport (girls seated on lawn), Mattie Coolidge and Alfred Davenport on horseback, and Mary Ellen Coolidge. Built *c.* 1845, it was later purchased by Mount Auburn Cemetery and demolished.

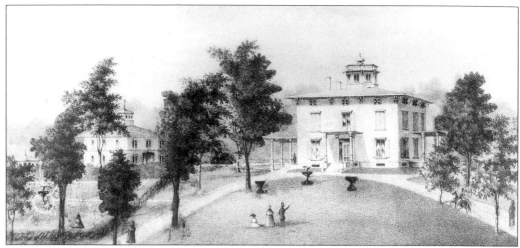

Named for the fountain on the lawn and the elevated land on Mount Auburn Street it occupied, Fountain Hill was built by Charles Davenport, a manufacturer of steam engines and coaches. It was sold in 1860 to railroad magnate Alvin Adams, founder of the Adams Express Company, who expanded the property into the eastern part of Watertown.

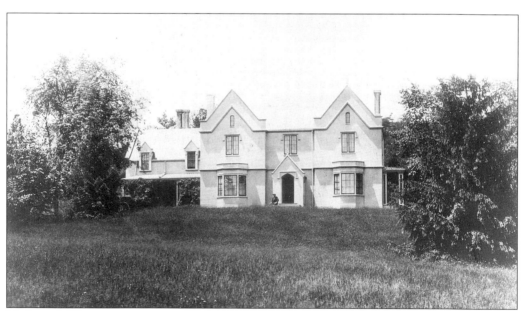

Nathaniel Whiting, a town civic leader and one of the founders of the Watertown Savings Bank, built a mansion in 1845 at what is now the corner of Church and Marshall Streets. He added to the beauty of his property by planting a row of beech trees between what is now Hawthorne and Palfrey Streets. Author Charles Dickens was entertained here and read from his works. The house was demolished in 1890.

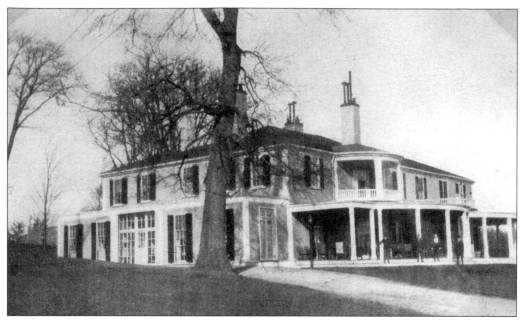

Built as a summer house for Harrison Gray Otis in 1808, the Oakley, named for the wealth of oak trees in the area, was located at the highest point in town. The mansion was expanded by Otis's friend and famous architect Charles Bulfinch. It was sold in 1825 to William Pratt. In 1890, it became the Oakley Country Club and golf course. The original mansion was destroyed in a fire in 1913.

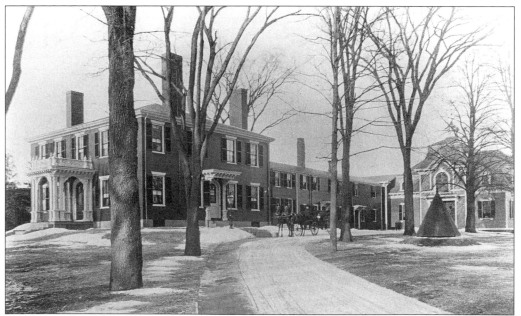

The Elms, a 10-room brick mansion, was built in 1804 and owned by cattleman Abijah White. The last owner was Harold Whitney, who died in September 1962. When an effort to save and move the house from the corner of Main Street and Whites Avenue to Saltonstall Park failed, the Whitney heirs auctioned off the contents. The property was sold to a developer for the Whitney Plaza apartment complex.

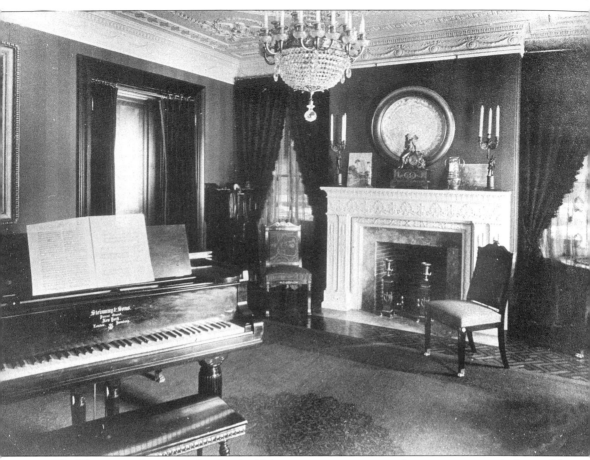

The Elms was a fine example of early-19th-century prosperity, with extensive grounds, beautiful rooms, and a large stable. The music room was the center of musical evenings for an eclectic group of young people. Included in this group was James Russell Lowell, who, enchanted with Maria White's beauty and intelligence, often walked along the river from Cambridge to Watertown to call on her. They shared an interest in poetry, music, and the causes of temperance and abolitionism. After their marriage in 1844, they lived in Elmwood, now the residence of the president of Harvard.

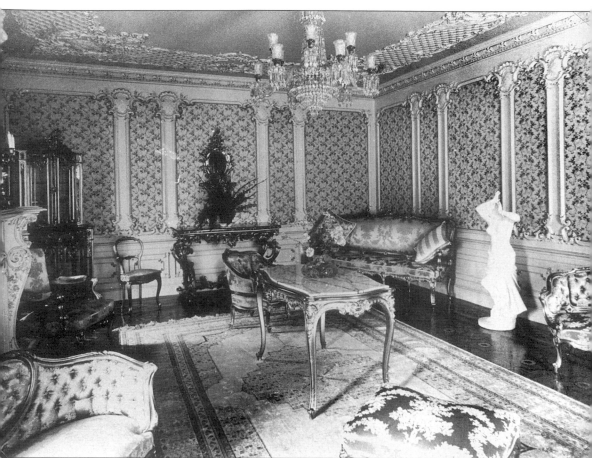

The Elms, located on Main Street west of Watertown Square, was home to cattle baron Abijah White. Pictured here is the drawing room of the Elms, lavishly furnished with an oriental carpet, French wallpaper, ornately carved furniture, and a chandelier. The Whites entertained groups of family and friends here, presenting plays and reciting poetry.

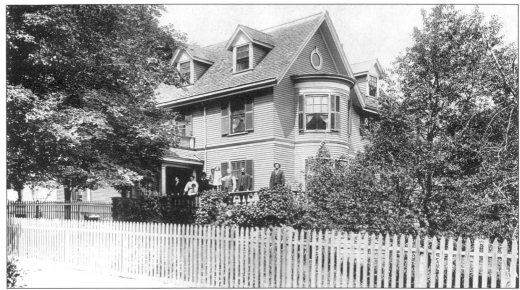

Photographer K.K. Najarian took this photograph of the Tovmassian family homestead at 81 Elm Street in 1913. Martin Tomassian, a president of the Historical Society of Watertown and uncle of Project SAVE's founder Ruth Thomasian, grew up here. Torn down in 1975, the house originally faced a cow pasture, later the site of the Hood Rubber Company and now the Watertown Mall. (Project SAVE Armenian Photograph Archives; courtesy of Carnig Thomason, Newton.)

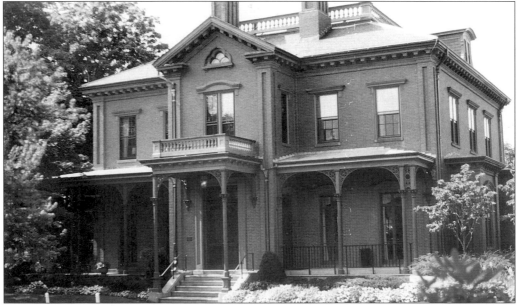

This extravagant structure was built in 1865 for Col. Thomas Rodman, commander of the Watertown Arsenal. The brick mansion is surrounded by seven acres that were landscaped by the Olmsted Brothers. There are 27 rooms, 11 fireplaces, 14-foot-high ceilings, herringbone-pattern wooden floors, and floor-to-ceiling windows. Many rooms have bas-relief, plaster trim moldings and ceiling medallions. Watertown acquired this property from the federal government in 1998. It is available for public functions.

Eight
CHURCHES AND
CEMETERIES

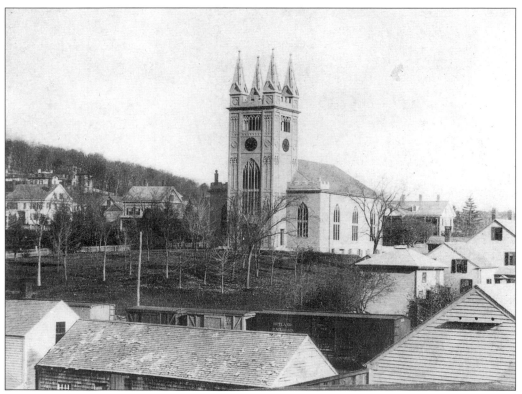

The First Parish was the second church organized in Massachusetts Bay Colony and, in 1631, was the first to protest taxation without representation. In 1835, First Parish legally separated from the town of Watertown and organized as a Unitarian parish under Rev. Convers Francis. This is the church they built at Church and Summer Streets. It is no longer standing.

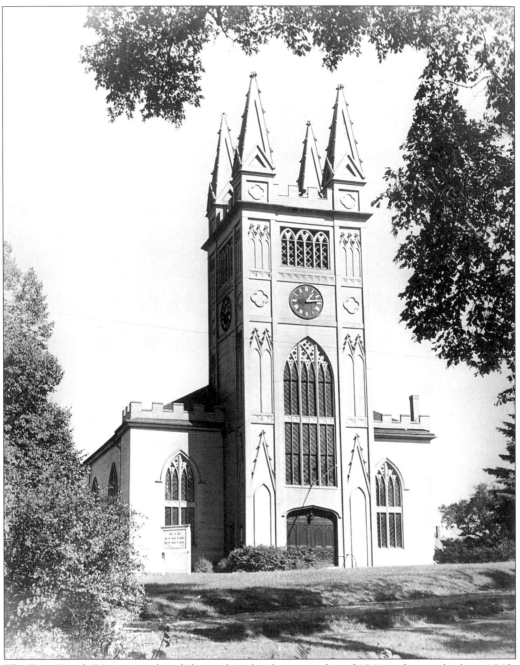

The First Parish Unitarian church burned in the disastrous fire of 1841 and was rebuilt in 1842. It was a notable example of Victorian Gothic architecture.

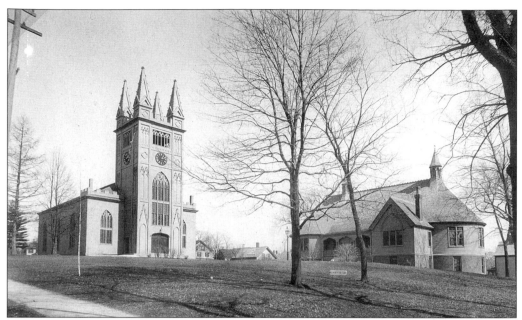

The First Parish Unitarian church stood at Church and Summer Streets. The old parish house (right) was designed by Charles Brigham and is now used by the congregation as its church. The old church building (left), completed in 1842, was demolished in 1975.

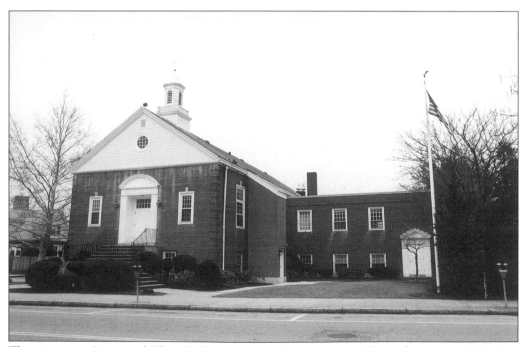

The Armenian Memorial Church (Congregational) opened in 1950 on the corner of Bigelow Avenue and Merrifield Street.

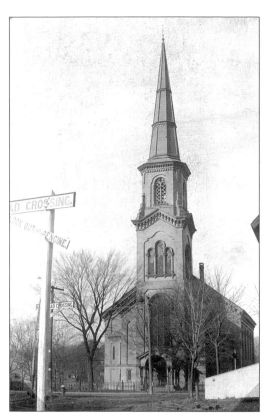

Baptists first came to Watertown in 1786, but not until 1827 did three young women from Newton establish a Baptist Sunday school here. In 1830, John Coolidge bought land on Mount Auburn Street and constructed the White Church on Baptist Walk. Of the church's 45 charter members, 32 were women. For 30 years, Baptists worshiped at that church and used the town landing on the Charles for baptisms. A second church was built in 1858.

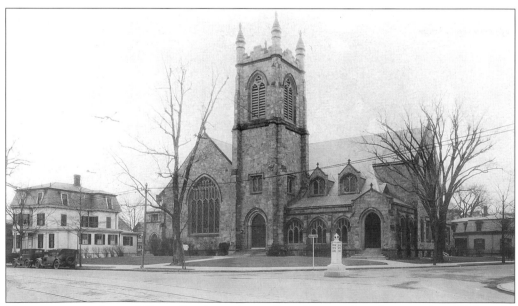

The present granite and Nova Scotia sandstone First Baptist Church opened in 1900 at the corner of Mount Auburn and Common Streets.

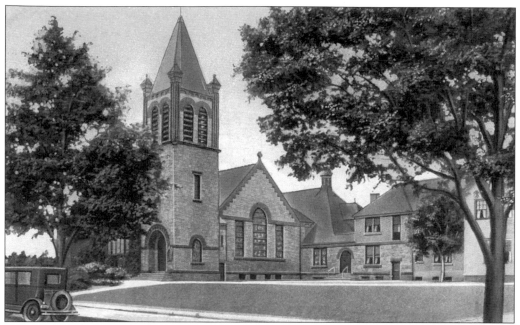

Watertown's first Methodist services were held in Leonard Whitney's home. In 1847, the Methodist Church of Watertown opened in the old Main Street Academy, opposite White's Avenue. In 1848, that building was sold to the Catholic Church and a new wooden church was built, capped with a copper weathervane from Paul Revere's shop. The congregation built a stone church on Mount Auburn Street in 1895 and renamed it St. John's Methodist in 1899.

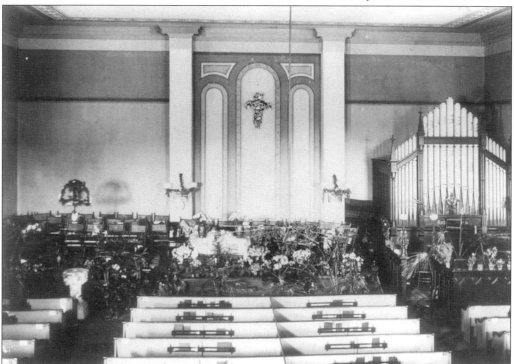

This is the interior of the old Methodist church located at Main and Cross Streets.

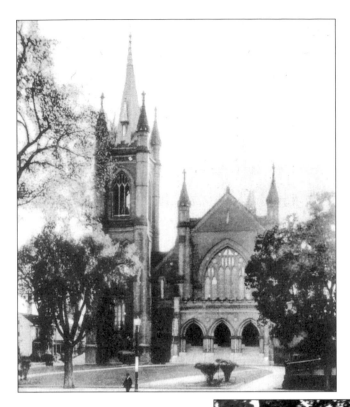

The first Catholic church in Middlesex County was located in Waltham in the 1830s. When feuding parishioners forced that church to close, the priest, Fr. Patrick Flood, moved to Watertown. For 10 years, he said mass in Watertown Square buildings. The expanding Irish immigrant congregation built two churches, St. Peter's Church (1848) and the present Gothic-style St. Patrick's (1901), which is shown here.

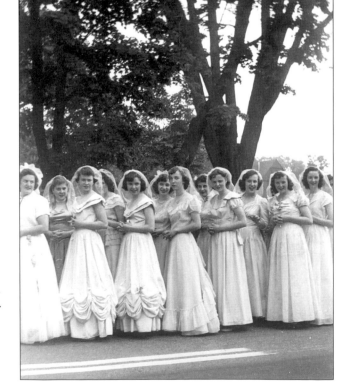

This is St. Patrick's annual May Procession c. 1950. By midcentury, two new parishes in Watertown were carved from St. Patrick's—Sacred Heart, in 1893, and St. Theresa of the Child Jesus, in 1927—as well as two parishes in Belmont, St. Luke's and Our Lady of Mercy.

In 1854, the Baptist and Methodist churches of Watertown hired Caroline Fenno of Newton to work as a Congregational missionary in their town. The resulting First Orthodox Church appointed Lyman Beecher as their first pastor. They dedicated the first church on Mount Auburn Street in 1857 but lost it to fire in 1861. The second church opened in 1862 and was in use until lightning struck the spire and made the building unsafe.

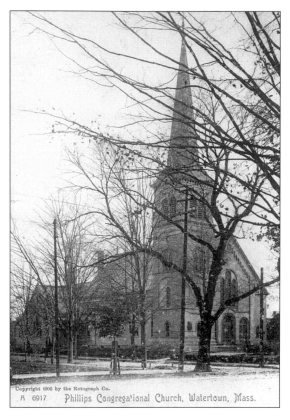

Phillips Congregational Church, Watertown, Mass.

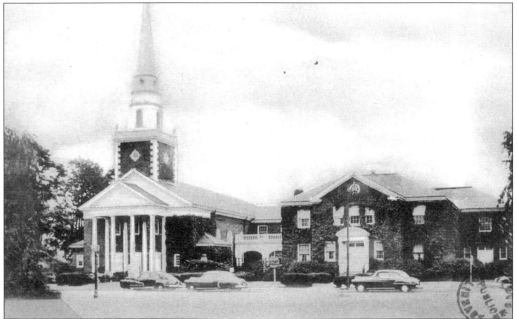

The present-day Phillips Congregational Church was the third Congregational church and was constructed in 1937 on the foundation of the original building. It was named for Watertown's founder and first pastor, Rev. George Phillips.

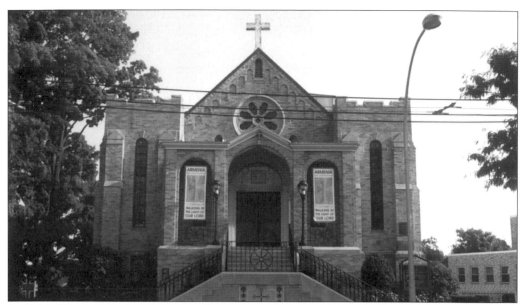

In 1924, Watertown Armenians working in area factories organized a religious community, led by Haigaz Akillian and Levon Kricorian. Mrs. Gulenia Nazar ran a small Armenian school between 1923 and 1933. Despite the Great Depression, St. James Armenian Apostolic Church, the first Armenian Apostolic church in greater Boston, was dedicated in 1937. The congregation also opened the Sahag-Mesrob Armenian School in 1933. In 1962, parishioners planned a new school and cultural center.

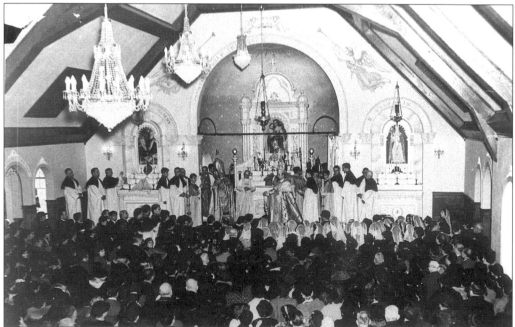

This is the dedication ceremony at St. James Armenian Apostolic Church. By the 1990s, it was New England's largest, with 2,000 families. Pastor Dajad Davidian told the *Watertown Sun* in 1994, "When I first became a priest, we were an immigrant church and I felt it was important to be as American as possible. Now, I try to be as Armenian as possible, because that's America."

Greek immigrants in Watertown founded a cultural center and school for their children upon arriving in Watertown. By 1937, they had organized the Greek Orthodox Church of Watertown on Arlington Street. The congregation met in the cultural center while the new church was being built on Bigelow Avenue. When the cornerstone was laid in 1950, the parish had 400 members.

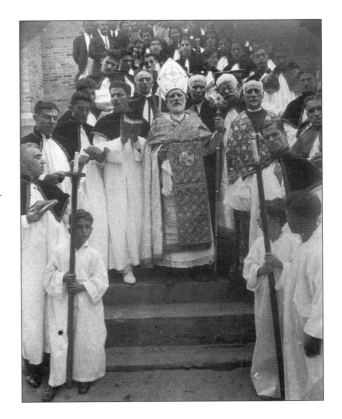

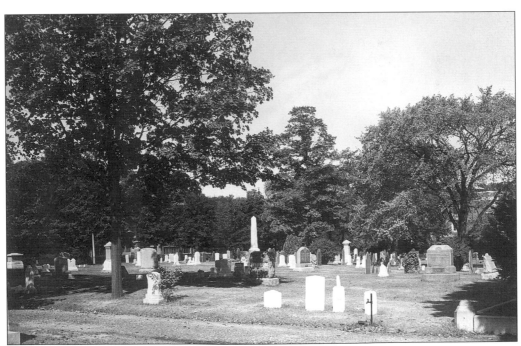

In 1754, Nathaniel Harris donated land at the corner of Common and Mount Auburn Streets for the Common Street Cemetery, shown here, and a meetinghouse, which was built in 1755.

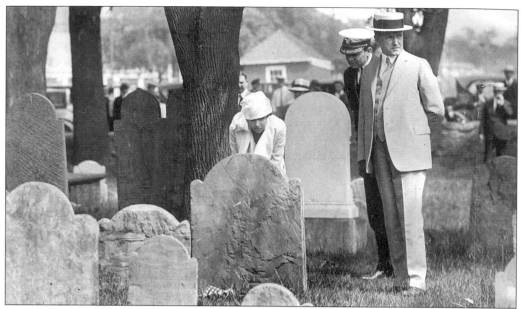

Pres. Calvin Coolidge and the first lady came to the Arlington Street Cemetery on June 29, 1925, to visit the graves of his ancestors, John and Mary Coolidge. The president and his entourage stepped over the low stone wall and walked through the long grass to the grave sites. Subsequently, the town improved the appearance of the cemetery by installing an iron fence around the graveyard and a new entrance gate.

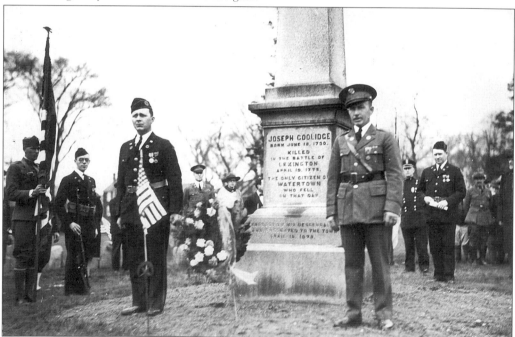

The Arlington Street Cemetery grave of Joseph Coolidge, the only Watertown man killed during the Battle of Lexington and Concord, on April 19, 1775, is marked with a 17-foot obelisk, erected by his descendants. This photograph shows a Memorial Day celebration at the grave site.

An interesting 18th-century slate grave marker records the death of Elizabeth Eve in the Arlington Street Cemetery. It reads, "Here lyes buried ye body of Mrs. Elizabeth Eve, wife to Mr. Adam Eve who died July 28th. 1735 in the 78th year of her age." Early in the 20th century, the Historical Society of Watertown restored or replaced a number of gravestones in the Arlington Street Cemetery and the Common Street Cemetery.

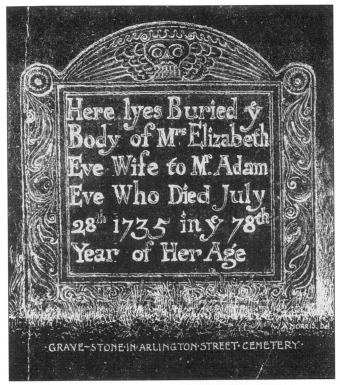

Mount Auburn Cemetery was established in 1831 by the newly formed Massachusetts Horticultural Society as the first garden cemetery in the United States. Some of the land used for the cemetery was once the farm of early Watertown resident Simon Stone. The new idea that a serene and natural setting was a desirable and pleasing resting place for loved ones led to the development of many more garden cemeteries throughout the country.

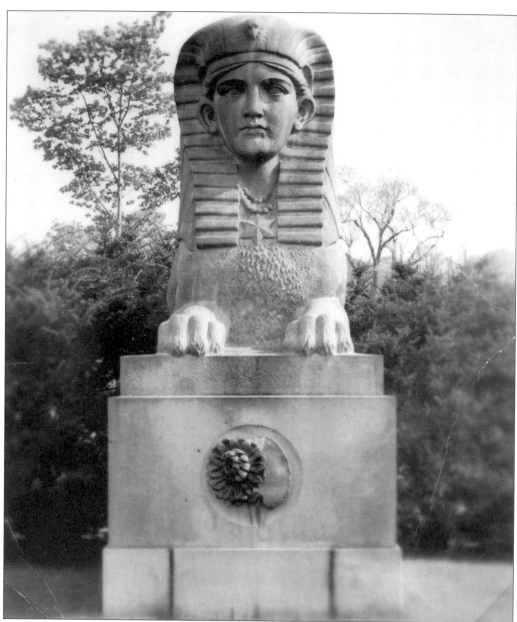

The *Sphinx*, located in front of Bigelow Chapel, was commissioned by Dr. Jacob Bigelow, one of the founders of Mount Auburn Cemetery. Sculpted by Martin Milmore after the Civil War, it commemorates the preservation of the Union and the destruction of slavery. In Bigelow's words, it combines "the strength of the lion with the beauty and benignity of woman." Mount Auburn Cemetery is known as an outdoor sculpture garden due to its numerous statues and monuments sculpted by well-known artists, including Thomas Ball, Edmonia Lewis, Henry Dexter, Edward Brackett, and Horatio Greenough. The cemetery's interesting and well-maintained landscaping and natural beauty contribute to its reputation as a magnificent arboretum. Its wide variety of trees and plants attracts many species of birds. Many notable figures are buried here, including Julia Ward Howe, Henry Wadsworth Longfellow, Mary Baker Eddy, Winslow Homer, and Charles Bulfinch.

Nine

SCHOOLS AND
PUBLIC BUILDINGS

The original town hall, shown here in 1868, was located on Main Street near Watertown Square. The special decorations celebrated the election of Ulysses S. Grant.

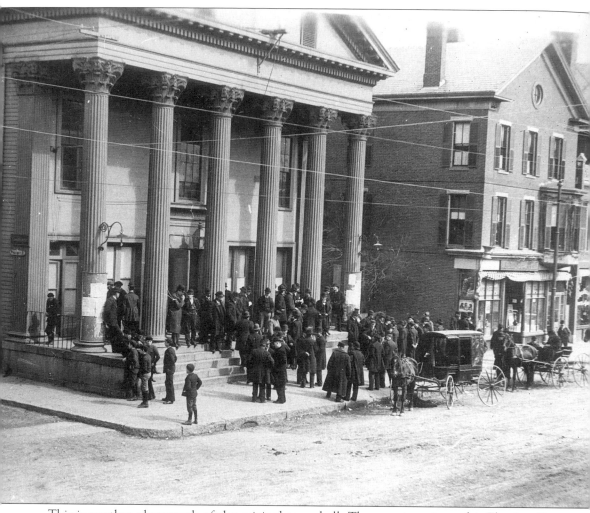

This is another photograph of the original town hall. The occasion pictured is Election Day in 1902.

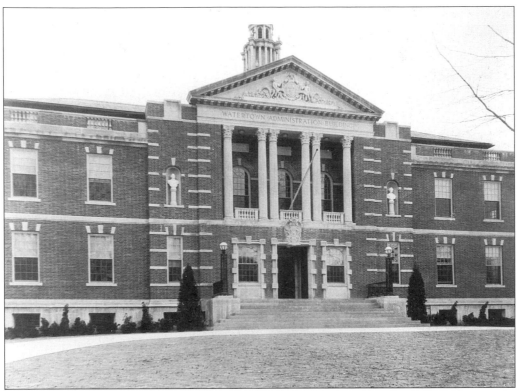

The Watertown Administration Building replaced the town hall in 1935 as space became too tight at the town hall. F.C. Sturgis was the architect for this Works Progress Administration project.

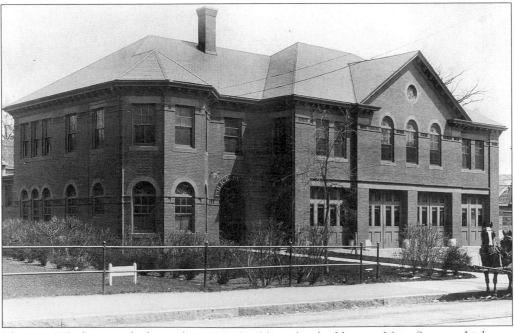

This *c.* 1935 photograph shows the original public safety building on Main Street, which was shared by the police and fire departments.

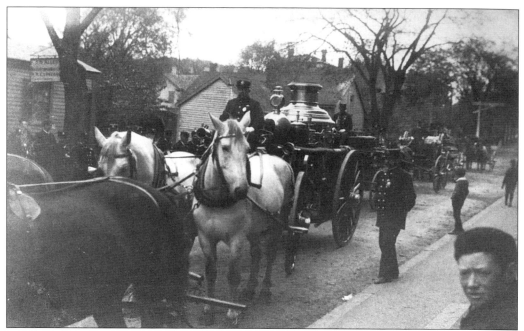

Members of the Watertown Fire Department are shown here marching in the 1892 Columbus Day parade.

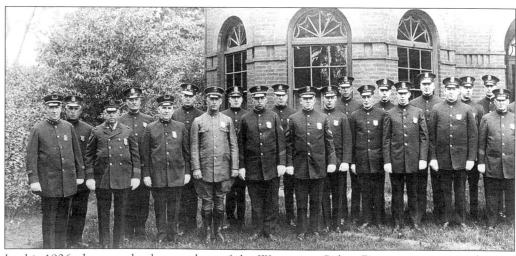

In this 1926 photograph, the members of the Watertown Police Department pose in front of the public safety building.

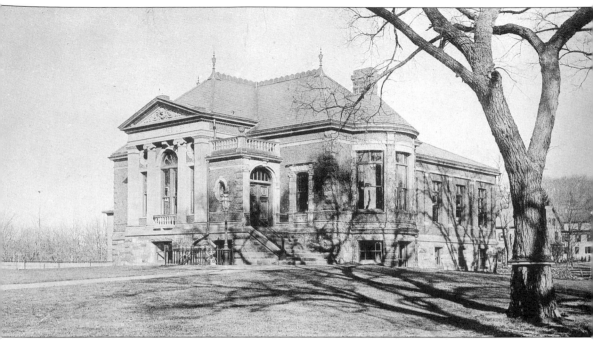

The Watertown Free Public Library was originally housed in the old town hall on Main Street. By 1884, enough money had been raised to build a library farther up Main Street on the site of a former shirt factory near present-day Saltonstall Park. Architects Shaw and Hunnewell designed the red-brick and brownstone building in the French Renaissance style. Additions to the building seen above were constructed in 1899, 1935, and 1956. This photograph of the library was taken *c.* 1900.

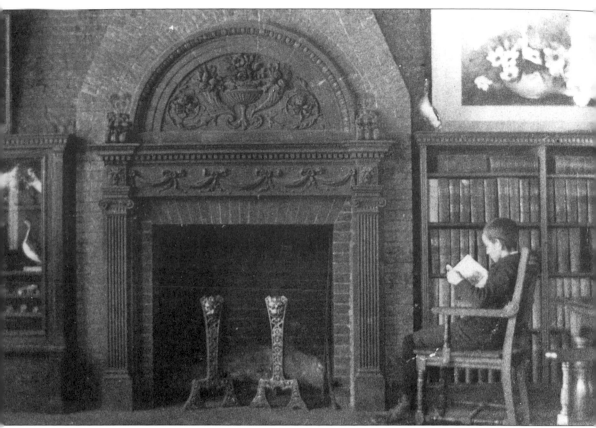

Watertown was an early implementer of a separate section for young people in the public library, creating a separate children's department *c.* 1900. Here we see a boy reading in front of one of the library's terra-cotta fireplaces.

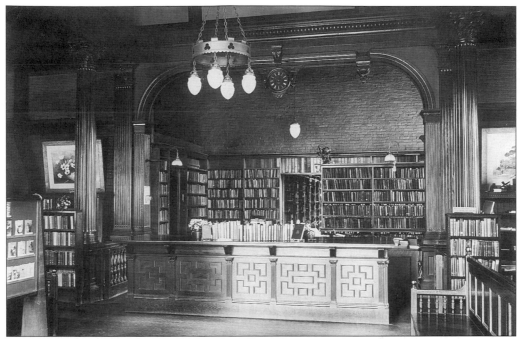

Certain elements seen in this *c.* 1900 photograph of the library's reference room are still intact today, including the clock and architectural details. This view, taken from the front door, looks toward the reference desk. Paintings by local watercolor artist Ellen Robbins hang on each side of the desk.

The West Branch Library was housed in the Browne School beginning in 1929, when the school committee agreed to build a wing with a separate entrance. It served as a school library while school was in session and as a branch of the public library in the summer into the 1970s.

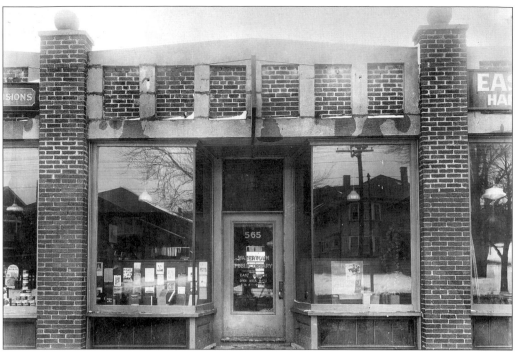

The East Branch of the Watertown Free Public Library opened in this storefront at 565 Mount Auburn Street in 1920.

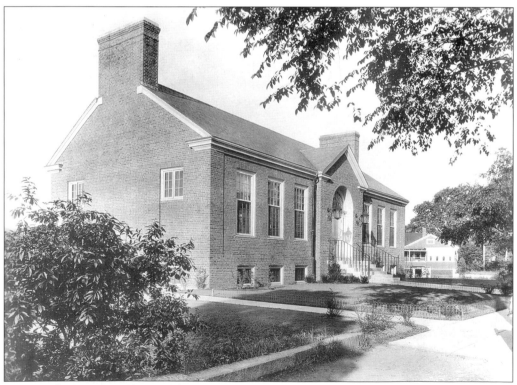

In 1927, the East Branch moved to its new location at 481 Mount Auburn Street.

Built in 1882, this was the first Lowell School. The building later became the North Branch Library.

The North Branch Library, originally housed in the abandoned Lowell School, stands at the corner of Orchard and Waverley Streets. In 1940, the town appropriated funds to have the library renovated. It is shown here shortly after the renovation.

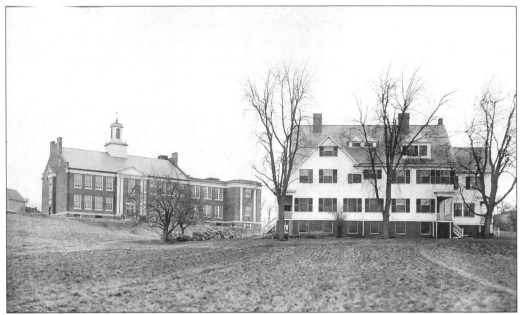

The building visible in the foreground of the photograph is the almshouse where the poor, orphaned, and insane were housed until reforms made poorhouses obsolete. In 1860, Massachusetts claimed the existence of over 200 almshouses (more than any other state). The building was demolished in 1931. Also pictured is the Lowell School.

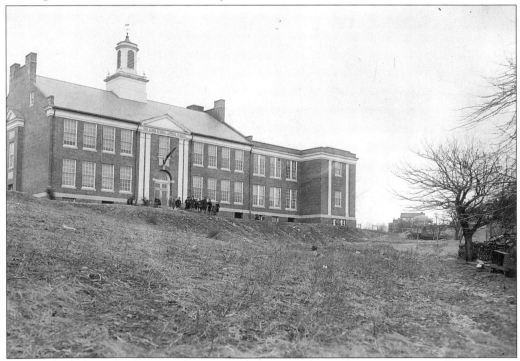

The James Russell Lowell School pictured here was built in 1927, replacing the older Lowell School built in 1883. The older school building became the North Branch Library. This photograph was taken *c.* 1930.

The Grant School, built in 1885 to help ease crowding in the town's schools, was named for Pres. Ulysses S. Grant and was located in Saltonstall Park near the current Boys and Girls Club building. By the end of World War II, it was no longer used as a school and was converted into housing. Note the town workers in the foreground of this photograph.

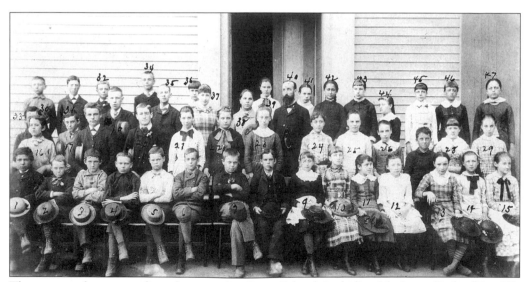

These are students attending classes at the Grant School, including M. Agnes Burke (No. 41), whose photograph as an adult can be seen on page 80.

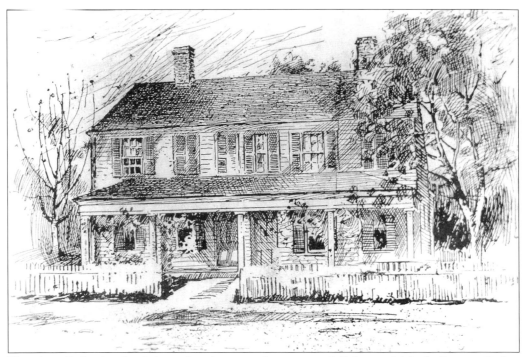

Theodore Parker's school (seen here) was at the corner of Galen and Maple Streets. Parker (1810–1860) was a prominent transcendentalist and abolitionist.

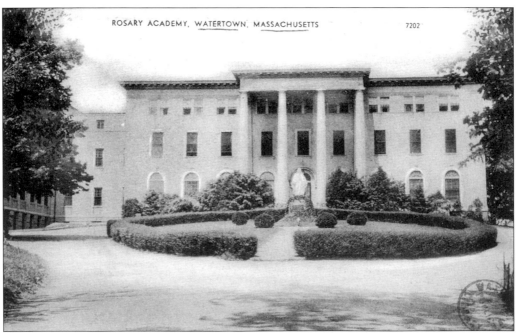

The Sacred Heart Institute (shown here), later renamed Rosary Academy, opened in 1911 on Lexington Street. This boarding school for girls was run by the Dominican Sisters of St. Catherine, based in Kentucky. The sisters also ran the Academy of the Infant of Prague, which became St. Dominic's Academy for boys in the Waverley section of Watertown and Belmont.

This old schoolhouse stood on Mount Auburn Street until 1922.

The West District School was located on Howard Street.

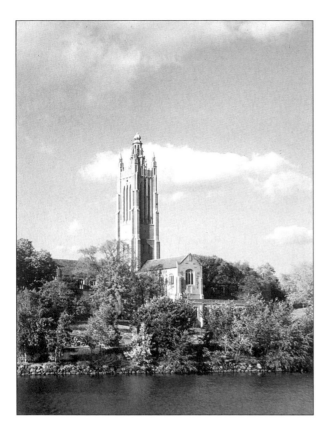

The Perkins School for the Blind, the first school for the blind in the United States, was chartered in 1829. The school moved from its original location in Boston to its present location on North Beacon Street in Watertown in 1912.

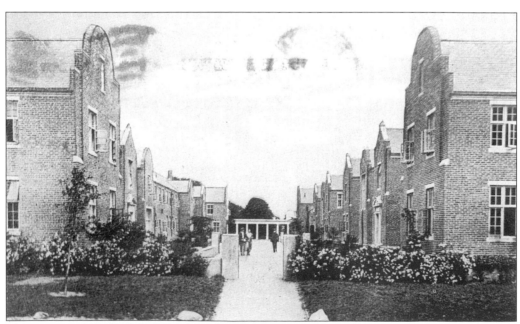

The campus of the Perkins School for the Blind, shown in an early-20th-century postcard view, is located on 40 picturesque acres on the Charles River (formerly the Stickney estate).

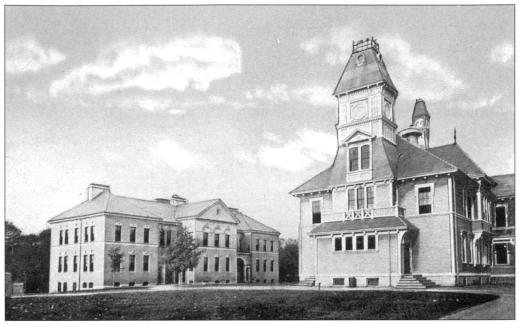

This postcard features the old Phillips School on the right and the newer Francis School on the left. The Phillips School was the original high school. It became an elementary school when a new high school was built. The schools were named for George Phillips (a founder of Watertown) and Rev. Convers Francis.

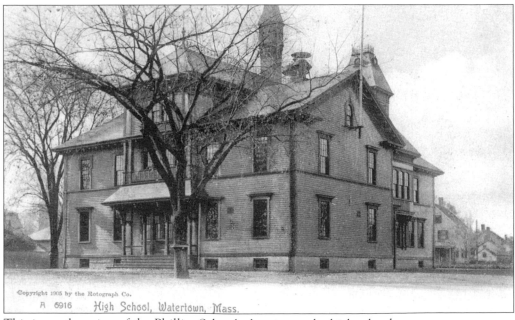

A 6916 High School, Watertown, Mass.

This is another view of the Phillips School when it was the high school.

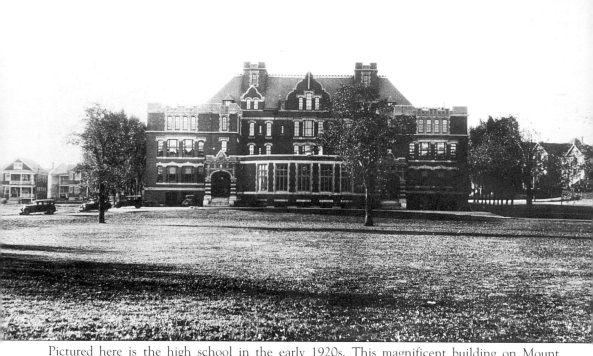

Pictured here is the high school in the early 1920s. This magnificent building on Mount Auburn Street was designed by architect Charles Brigham, who donated the plans to the town. Brigham also designed the town seal. Later, the building was the East Junior High School.

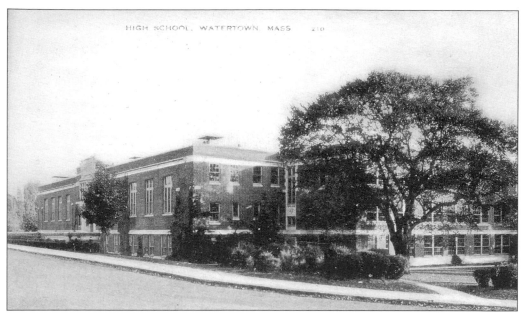

This postcard shows the current high school, which is located at the corner of Columbia and Common Streets.

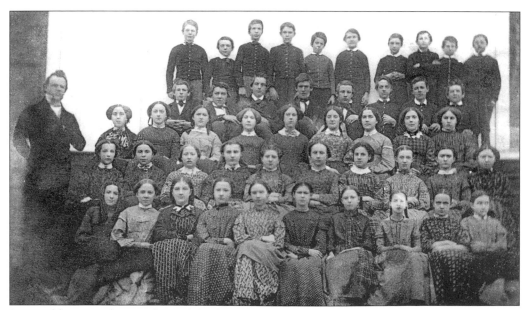

Pictured here are the members of the first class of Watertown High School in 1854. Architect Charles Brigham, who designed the town seal and the high school (later the East Junior High School), is the shortest boy in the back row of this photograph.

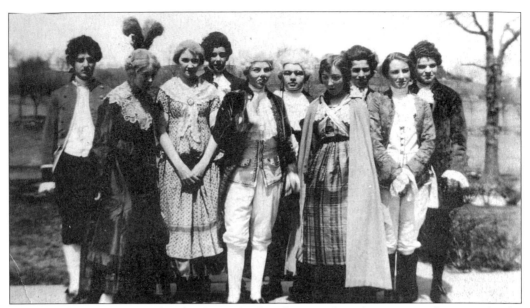

Students of Watertown High School pose for this photograph in the costumes they wore for the class play in 1918.

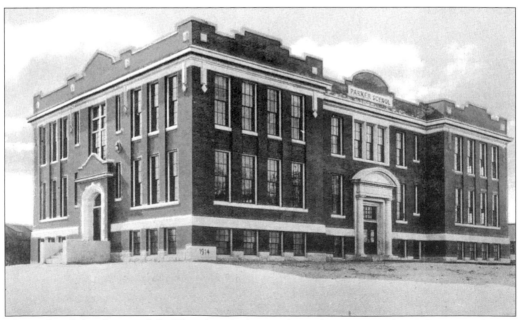

The Parker School, named for Theodore Parker, is shown here. Located on Watertown Street, the school ceased operation in 1979 and was converted into condominiums.

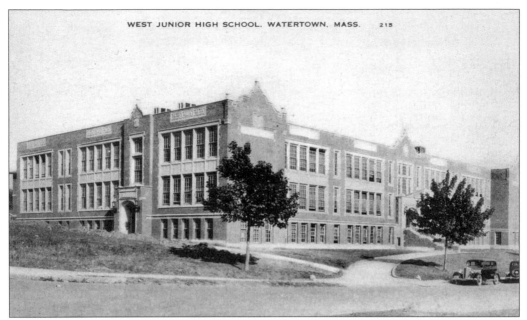

The West Junior High School (seen here) was built in 1922 but needed an addition by 1927.

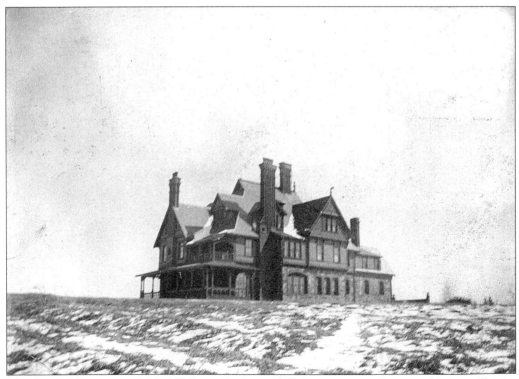

The Payson House on Oakley Hill was built c. 1880. Later, it was the site of Mount Trinity Academy, then the Protestant Guild for the Blind. In 1984, it was transformed into condominiums.

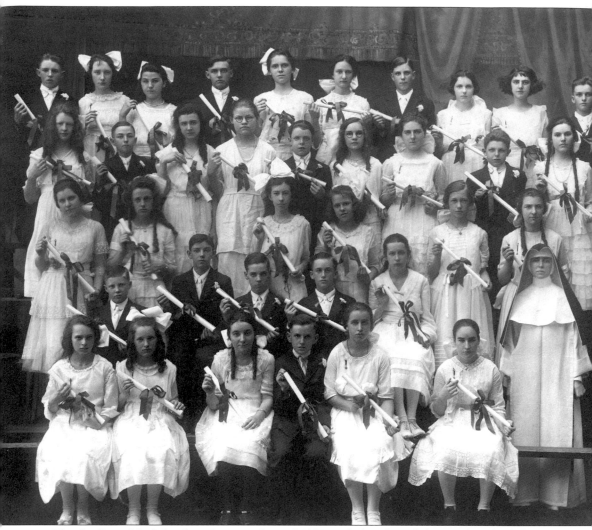

The St. Patrick's School graduating class of 1921 includes, from left to right, the following: (first row) Catherine Roche, Catherine Nolan, Catherine Morrell, Edward McNamara, Mary Condon, and Helen O'Brien; (second row) Francis Troy, Walter Burke, Thomas Maloney, Arthur Campbell, and Mary Gleason; (third row) Catherine Devlin, Anna O'Toole, Mary Hanley, Gertrude Collins, Catherine Cochrane, and Florence MacNeil; (fourth row) Anna Vahey, Robert Boyle, Catherine Cavanaugh, Victoria Cooper, James Kelley, Catherine Walsh, Gertrude Foley, William Davis, and Florence White; (fifth row) Arthur Morley, Susie Blackburn, Margaret Driscoll, Milton Peltier, Marie Gleason, Ruth Scanlon, Herbert Smith, Mary Quinn, Agnes Bolduc, and John Kennedy.